MW00559278

SEEING THE NEW SOUTH

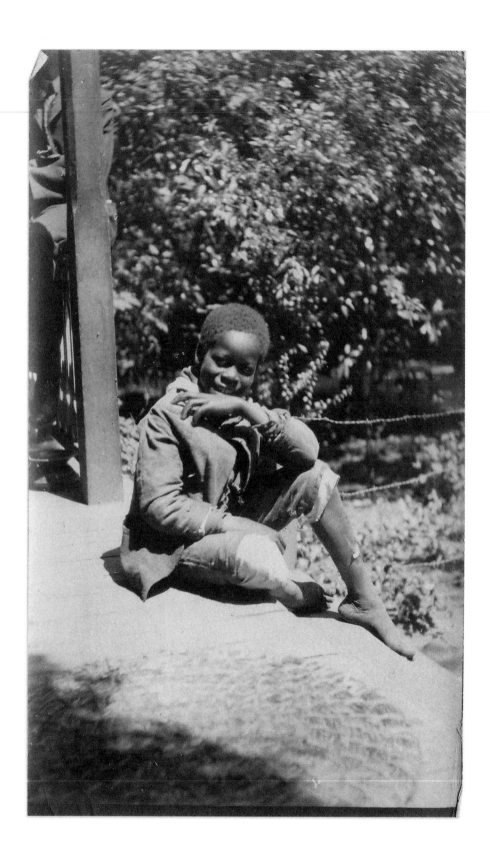

SEEING THE NEW SOUTH

Race and Place in the Photographs of

ULRICH BONNELL PHILLIPS

Patricia Bellis Bixel and John David Smith

THE UNIVERSITY OF SOUTH CAROLINA PRESS

Published by the University of South Carolina Press
Columbia, South Carolina 29208

www.sc.edu /uscpress

Manufactured in the United States of America

22 21 20 19 18 17 16 15 14 13 10 9 8 7 6 5 4 3 2 1

LIBRARY OF CONGRESS CATALOGING-IN-PUBLICATION DATA

Phillips, Ulrich Bonnell, 1877–1934.
Seeing the new South : race and place in the photographs of Ulrich Bonnell Phillips /
Patricia Bellis Bixel and John David Smith.
p. cm.
Includes index.
ISBN 978-1-61117-105-1 (cloth)
1. Southern States—Social conditions—1865–1945—Pictorial works. 2. Southern States—Social life
and customs—Pictorial works. 3. African Americans—Southern States—History—Pictorial works.
4. Plantation life—Southern States—History—Pictorial works. 5. Phillips, Ulrich Bonnell, 1877–1934.
I. Bixel, Patricia Bellis, 1956– II. Smith, John David, 1949– III. Title.
F210.P55 2013
305.896'073075—dc23 2012022354

*Frontispiece: Young boy on a porch. Photograph probably by Robert E. Williams. Ulrich Bonnell Phillips
Papers (MS397), Manuscripts and Archives, Yale University Library, MADID #44180.*

For Robert Williams Jr., H.C. Hall, and all local photographers—amateur and professional—who capture the joys, sorrows, and daily lives of their communities

—P.B.

For David P. Gilmartin, William Kimler, and
Richard W. Slatta, dear colleagues from State

—J.D.S.

Contents

PREFACE

When historian David M. Potter transferred "a case containing photographic slides illustrating aspects of southern life" to the Yale University Library in 1961, the small wooden box attracted little attention. Potter had been one of Ulrich Bonnell Phillips's last graduate students at Yale, and the Phillips family had given him assorted scholarly materials after the historian's death. Potter's eventual donation was part of a larger group of Phillips's research notes, transcripts, and documents that the library added to its collection in the early 1960s, and this small container of lantern slides was processed into the Phillips holdings along with everything else. Many of the images had been included in Phillips's *Life and Labor in the Old South* (1929), and their lantern-slide format suggested that Phillips may have used them as part of his lectures.[1]

Besides the lantern slides, correspondence in the Phillips Papers hinted at the existence of a second, larger cache of images. In a letter dated September 8, 1961, Mabel Phillips Parker, Phillips's daughter, offered another box of "Photographs and Plates" collected by her father that "appear to be mostly concerned with the South though there are a few African items."[2] Howard Gotlieb, then librarian of historical manuscripts, responded that the proffered donation would be more appropriate for the Peabody Museum of Natural History, also in New Haven and a Yale affiliate, where he judged the items would be better preserved.[3] Phillips's family followed Gotlieb's advice and sent the materials to that institution, where the boxes rested undisturbed until 2006, when a close reading of letters in the Phillips Papers noted the reference to other items. A search ensued, and archivist Barbara Narendra of the Peabody Museum located the box in one of the museum's storage areas. It was subsequently transferred to the Manuscripts and Archives department of Yale's Sterling Library to join other Phillips materials.

An inventory of the acquisition revealed 377 prints, 122 negatives, and 32 additional lantern slides. While some duplicates occurred, both within the new materials and with the 60 lantern slides already in the Phillips Papers, there were also hitherto unseen and unpublished images dating from the late nineteenth century to 1931, including a small set of negatives of African scenes that Phillips photographed in 1930, during his Albert Kahn Foundation fellowship year.[4] Taken together, the lantern slides, the newly recovered prints and negatives, and the random photographs contained elsewhere in the Phillips holding form a sizeable visual archive built over the course of a career spanning decades. The time and effort devoted to accumulating these pictures demonstrate Phillips's belief in the value

of images as evidence as well as his methodological commitment to using the most modern and "scientific" documentary techniques available to him at the time. Notations on many of the prints, captions, and the historian's correspondence help to integrate these sources into Phillips's far larger textual legacy. Phillips clearly appreciated the value of visual testimony.

Examined in detail, Phillips's photographs document a wide array of places and activities associated with his beloved South. The greatest number of images records a broad spectrum of the built environment in the region. Selections include stereotypical plantation homes, outdoor cotton presses, farmhouses, and former slave quarters. Pictures of a wide range of log, clapboard, and smaller brick structures detail the variety of housing in use in the early twentieth century. Derelict or abandoned structures memorialized in the collection prove particularly evocative. That Phillips saw fit to record such remains testifies to both his belief that the South needed to move beyond nostalgia in shaping its future and his sometimes wistful regret for lost aspects of plantation culture.

Southern work practices—chiefly agricultural—also figure significantly in Phillips's photographic archive. Cultivation of sugarcane, rice, and cotton is represented as is the process of cypress logging on Bayou Teche and Bayou Black, Louisiana. In these images of field work, harvesting, and transportation, Phillips recorded not only the agricultural staples but also those who grew them. Phillips was obviously interested in each step of southern agricultural production. Elsewhere within the archive, photographs of hands at work, portraits, a series set at a riverboat landing, images showing the processing and marketing of cotton, and depictions of African Americans in downtown Milledgeville, Georgia, on a Saturday in 1904 offer diverse glimpses of southern daily life. The collection also includes images from Camp Gordon, Georgia, where Phillips served as associate secretary of the YMCA's educational services during World War I.[5] Handwritten notes on the backs of some prints or in the margins of mounted images often explain the background or occupation of the subject and suggest that Phillips took some of the pictures, received detailed accounts of the images from correspondents, or obtained copies from southern commercial studios.[6]

Choosing images for this volume was complicated, and the photographs published here ultimately passed through three filters. Phillips initially chose particular views for reference, publication, classroom use, or presentations to general audiences. Then his descendants donated images to Yale, no doubt reviewing the collection before passing it on. Finally the authors of this work selected images that reflect Phillips's interpretation of the South but also open themselves to alternative readings of their subjects and the region. In a few cases, questions of provenance or copyright kept otherwise intriguing views out of this work. Phillips was meticulous in crediting sources when he used images in publications, but his working collection sometimes lacks relevant information as to where or from whom he obtained particular prints. Visual interest and the availability of information about an image—captions, notations, photographers, or other textual context—were also

factors that influenced inclusion. Only photographs are published here, no drawings, tables, maps, or other illustrative materials that Phillips gathered for his holding.

Phillips's racial views played a crucial role in his scholarship—an aspect of the historian's work that has not escaped the careful scrutiny of his many critics. Phillips's well-known, early twentieth century, Jim Crow—era understanding of race, especially what he considered rigid African American race traits, influenced his decisions in selecting subjects for his photographs and for illustrations in his writings. This book is the first work to engage with Phillips's photographs. Considered within Phillips's interpretive context, Phillips's visual materials depict people of color in patronizing ways. His collection of plates, prints, and slides contains a disproportionate number of stereotypical Old South plantation views, pseudoscientific anthropological diagrams taken from then outdated texts, and contemptuous captions. His personal understanding of African Americans as childlike and of ultimately limited potential runs through his photographic collection much as it punctuates his scholarship. Nevertheless, like his historical interpretations, Phillips's photographic images hold value for what they convey about Phillips as historian, about Progressive Era southern historiography, and about how educated, highly influential whites in the early twentieth century understood and portrayed African Americans. In addition, by preserving this visual material, Phillips and his descendants inadvertently protected a valuable sampling of pictures created by amateurs, African American and white commercial photographers practicing in the region, and Phillips himself. Collectively the images provide a thought-provoking array of visual representations of the South and its folk.

The Phillips materials thus offer a tremendous opportunity to explore a recently uncovered cache of historical photographs and enrich our awareness of a particular historian and the region he loved and studied. Taken at face value, the pictures may simply reinforce Phillips's vision of the New South as a land wedded to the past but in need of agricultural and economic planning and strong educational leadership. But the photographs also provide opportunities for alternative readings—stories of growth and progress, hard work and pride, and repression and rebellion.

This book grows from scholarship exploring how historians may use photographs.[7] Images should be recognized as both information sources and material culture and be subjected to close analysis in each mode. We gain real information from the content of a picture, but we also reap knowledge from understanding the circumstances of production, the photographer, and the image's ultimate use. Beyond that, photographs, as objects in themselves, are open to investigation as items that both reflect and construct the cultures of their production. As an archive apart from Phillips, these images possess a level of cultural authority that may challenge or reinforce prevailing ideas about the historian and the South. The collection necessarily reveals a South and southerners—and Africans and African Americans—that are autonomous and outside the historian's narrowly defined vision. They may stand alone, independent of Phillips and his texts.

Two chapters accompany these photographs. The first broadly examines Phillips's collecting and use of the archive, both his acknowledged intentions and other implicit attitudes as revealed by correspondence, presentations, notes, and captions. The second explores an assortment of the images in greater detail, acknowledging specific meanings assigned by Phillips as well as other possibilities, considering the pictures as both information and objects. The photographs document much about the South from the late nineteenth century into the 1920s, and Phillips's African and African American photographs offer particular insights into the historian and his practice. At the same time, the images have lives of their own, separate from the historian and his interpretations, and they may be used for purposes far different from those Phillips intended.

One of the pictures included in Phillips's *Life and Labor in the Old South* (fig. 13) shows an outdoor cotton press, an awkward, massive structure in the middle of a field. Function is implied; there are no bales stacked beside it or farmers and wagons waiting with loose cotton to compact. In the illustrations list at the front of the book, Phillips described in great detail how such a press operated while noting that it was "already antiquated." In a nutshell, this image and its explication capture the essence of U. B. Phillips's methodology and subsequent understanding of the South. This view of an outdoor cotton press records an integral component of southern agriculture and a potent symbol of the region's economy along with the caveat that its time had passed. Like the outdated machinery, Phillips's historic South lived on through its surviving architecture, social relations, and economy. At once a progressive path breaker of historical methods, Phillips at the same time spun his sources to support his racist vision of the southern past and future. We know now that, in addition to widely promoted and developed documentary collections, the historian also accumulated photographs, using what was for him the most modern of technologies to capture what he wanted to say about the South.

This book seeks to begin a conversation about Phillips and his images. The discussions here are by no means exhaustive, and much of the extant collection in the Yale archive awaits future researchers and scholars. Taking these images as a starting point, however, prompts several questions. How are we to understand the images he saved? What can they tell about us the South—its historic architecture, its post–Civil War economy, and its white folk? What do the images convey about African Americans in the early twentieth century and Africans in 1930? Where does this collection fit within the broader world of images from the period? Are they valuable even though their use supported interpretations we now reject? What new archives may be constituted by selecting and combining images from this and other collections?

NOTES

1. David M. Potter to Howard Gotlieb, July 27, 1961, Ulrich Bonnell Phillips Papers (MS397), Manuscripts and Archives, Yale University Library (hereafter cited as Phillips Papers, Yale).
2. Mabel Phillips Parker to Howard Gotlieb, September 8, 1961, Phillips Papers, Yale.

3. Gotlieb to Parker, September 18, 1961, Phillips Papers, Yale.

4. "Miscellanea," n.d., Phillips Papers, Yale.

5. Merton Dillon, *Ulrich Bonnell Phillips: Historian of the Old South* (Baton Rouge: Louisiana State University Press, 1985), 102. On Phillips's racial myopia while at Camp Gordon, see Adriane Lentz-Smith, *Freedom Struggles: African Americans and World War I* (Cambridge, Mass.: Harvard University Press, 2009), 1–2, 11.

6. "Miscellanea," n.d., Phillips Papers, Yale.

7. See for example "Roundtable: American Faces: Twentieth-Century Photographs," *Journal of American History* 94 (June 2007): 97–202; Michael Coventry, Peter Felten, David Jaffee, Cecilia O'Leary, and Tracey Weis, with Susannah McGowan, "Ways of Seeing: Evidence and Learning in the History Classroom," *Journal of American History* 92 (March 2006): 1371–1402.

Acknowledgments

This book results from years of work and the authors have accumulated many debts along the way. For more than a decade, the Manuscripts and Archives department at Sterling Memorial Library, Yale University, has provided exceptional support as both authors pursued research in the Ulrich Bonnell Phillips Papers (MS397), Manuscripts and Archives, Yale University Library. Margaret K. Powell, the W. S. Lewis Librarian and executive director of Yale's Lewis Walpole Library, worked early on with John David Smith to explore the role, relevance, and possibility of publishing Phillips's lantern slides. More recently Judith Schiff and later Christine Weideman, William Massa, and the archives staff encouraged, supported, and facilitated our access to and publication of these photographs. John B. Boles was a catalyst for this project, introducing the authors and subsequently offering ongoing encouragement. Many archivists have helped to track down photographers, locations, and relevant documents. David M. Hovde at Purdue University, Nelson Morgan of the University of Georgia Libraries, and Harry Miller and Peter Gottlieb of the Wisconsin Historical Society all helped to fill gaps in what we know about Phillips and his photographs. Christopher Stokes, formerly historian at the Washington Memorial Library in Macon, Georgia, took the search for Georgia commercial photographers as his own and supplied extremely valuable information on short notice. Both authors thank Alexander Moore, acquisitions editor at the University of South Carolina Press, for his enthusiasm for this book and for his support at a crucial moment in its history.

Patricia Bixel would especially like to thank the Professional Development Committee at Maine Maritime Academy for ongoing financial support for the Phillips project. They provided funding to digitize the original sixty lantern slides and underwrote recurring summer research trips to New Haven. Rebecca Whitney, former reference librarian at Nutting Memorial Library, is an interlibrary-loan savant and worked miracles to bring sometimes obscure southern publications to downeast Maine. Early thinking about Phillips and his pictures greatly benefited from insights provided by the hardy southern historians in New England; their timely input gave the project a shove when it needed it most. Dana Anderson, Jocelyn Boucher, Sarah Hudson, Susan Loomis, and Laurie Cleghorn Stone of Maine Maritime Academy have been unfailingly supportive. Cynthia Lynn Lyerly has offered ongoing encouragement even as she pursued her own manuscript travails, and Eric Bixel good-naturedly endured the loss of his wife and dining table to the Phillips photographs and manuscript. Finally John David Smith has been relentless in his efforts to bring

Phillips's photographs to a broader audience. For many years, he saw the photographs as a significant source of information and insight into the southern historian, and his knowledge of Phillips supplied the essential foundation for exploring these fascinating images. Working with John David Smith has been a superb collaborative opportunity, a great pleasure, and an ongoing education.

John David Smith wishes to thank the late Mabel Phillips Parker, Ulrich B. Phillips's daughter, for welcoming him to her home in 1974 and for sharing recollections, insights, and research materials with him. Over several decades two fellow Phillips scholars and friends—John Herbert Roper and Merton Dillon—cheered him on while making their important scholarship on Phillips available to him. Glenda Gilmore always expressed keen interest in this project. J. Vincent Lowery and James Humphreys generously shared the fruits of their research on southern historians. Ann Davis and her talented interlibrary-loan staff at J. Murrey Atkins Library, University of North Carolina at Charlotte, worked miracles in securing Phillips materials. Sylvia A. Smith patiently backed yet another project and continues to wait for the last word to be written on Ulrich B. Phillips. This work was supported in part by funds provided by the University of North Carolina at Charlotte and the College of Liberal Arts and Sciences.

CHRONOLOGY

1877

Ulrich Bonnell Phillips born in La Grange, Georgia, November 4

1893

Completes curriculum at the Tulane Preparatory School
Enters the University of Georgia

1897

Awarded an A.B. degree by the University of Georgia

1898

Studies with Frederick Jackson Turner during the University of Chicago summer term

1899

Awarded an A.M. degree by University of Georgia
Enrolls at Columbia University

1901

Ph.D. dissertation, "Georgia and State Rights," awarded the Justin Winsor Prize

1902

Elected president of the Federation of Graduate Student Clubs
Awarded a Ph.D. by Columbia University
Dissertation published by the American Historical Association
Appointed instructor at the University of Wisconsin

1903

Proposes to reform the Georgia Historical Society
Teaches at the Summer School of the South in Knoxville, Tennessee
Assesses the public records of Georgia for the American Historical Association

1904

Begins a campaign to reform southern education and agriculture on the Wisconsin model

Joins Richard T. Ely's American Bureau of Industrial Research, University of Wisconsin

Receives a research grant from the Carnegie Institution of Washington, D.C.

Teaches summer school at the University of Georgia

1907

Promoted to assistant professor at the University of Wisconsin

Teaches summer school at the University of Kansas

Appointed visiting professor at Tulane University

1908

Publishes *A History of Transportation in the Eastern Cotton Belt to 1860*

Promoted to associate professor at the University of Wisconsin

Appointed chairman of the Department of History and Political Science at Tulane
 University

1909

Publishes *Plantation and Frontier, 1649–1863*

1911

Marries Lucie Mayo-Smith, February 22

Appointed professor at the University of Michigan

1913

Publishes *The Correspondence of Robert Toombs, Alexander H. Stephens, and Howell Cobb* and
 The Life of Robert Toombs

1914

Elected to the executive council of the American Historical Association

1917

Joins the staff of the YMCA at Camp Gordon, Georgia

Elected a fellow in the Royal Historical Society

1918

Publishes *American Negro Slavery*

1924

Appointed visiting professor at the University of California, Berkeley

1925

Teaches summer school at Harvard University

1927

Publishes (with James David Glunt) *Florida Plantation Records from the Papers of George Noble Jones*
Delivers the commencement address at the University of Georgia

1928

Awarded a $2,500 book prize from Little, Brown and Company for *Life and Labor in the Old South*
Presents "The Central Theme of Southern History" at the American Historical Association annual meeting

1929

Publishes *Life and Labor in the Old South*
Awarded a $5,000 Albert Kahn Foundation Fellowship for world travel
Appointed professor at Yale University
Elected to the executive council of the American Historical Association
Receives an honorary doctor of letters degree from Columbia University
Receives an honorary master of arts degree from Yale University

1930

Tours Japan, Ceylon, and Africa

1931

Attends a conference of southern writers meeting at the University of Virginia
Attends a rural-education conference at Tuskegee Institute in Alabama
Presents the keynote address at the North Carolina State Literary and Historical Society, Raleigh

1932

Delivers a lecture series at Northwestern University
Teaches summer school at the University of California, Berkeley

1934

Dies in New Haven, Connecticut, January 21

1939

The Course of the South to Secession published posthumously

Seeing the New South

INTRODUCTION

The dust-jacket copy on the Grosset & Dunlap edition of Ulrich Bonnell Phillips's 1929 award-winning *Life and Labor in the Old South* describes the book as "the classic study of what life was really like in the antebellum South." The cover art includes stereotypical images of a white-columned classical-revival-style mansion draped in Spanish moss. Women in crinoline gowns adorn the portico. Black people work in cotton fields and smoke billows from a steamboat plying a river on the horizon. There could be no more idealized image of the plantation South.[1]

Phillips took pains to illustrate his book, a richly textured social history of his native region, with carefully selected black-and-white photographs of various plantation houses, slave quarters, urban dwellings, and all manner of log cabins and homes, including wood shacks, which he classified as "unsophisticated styles" and "informal types." Not simply interested in portraying the romanticized world of the southern gentry and their slaves, Phillips detailed what he termed the "plain people," those mountain folk whose lives "ranged only from homespun comfort to habituated eking of the barest livelihood."[2] His task was to describe "what life was really like in the antebellum South."

In addition to illustrations of buildings of the rich and poor, *Life and Labor* contains images of agricultural structures and equipment—tobacco barns, a cotton-gin house, and a cotton-baling press. Phillips's understanding of the Old South lived on as much through its surviving architecture and its extant plantation records as through its Jim Crow system of race relations and its depressed, agriculturally driven cotton economy. While prone to exalt the richness of the southern past and a firm believer in the cultural and intellectual superiority of white people over black, Phillips nonetheless recognized the region's structural weaknesses and the limitations imposed by the South's historic "Negro problem." For decades, ever since his days as a young Progressive at the University of Wisconsin, he had committed himself to shaping that past into a foundation for a more prosperous future.[3]

Much of Phillips's reputation as a historian rests upon his pioneering work acquiring, editing, and utilizing the documentary records of the southern past.[4] He grounded his interpretation of the South upon an extensive underpinning of archival materials, but his

conclusions about southern society reflected biases of his day and his place. This was inescapable, Phillips said. "Every line which a qualified student writes is written with a consciousness that his impressions are imperfect and his conclusions open to challenge," he explained early in *Life and Labor*. "When I read of Howard Odum's *Black Ulysses*, of DuBose Heyward's *Porgy*, of Stephen Benét's plantation mammy and her mistress, esteem for their creations is mingled with chagrin that my fancy is restricted by records." Phillips insisted that the historian's reliance on documents set him apart from the traditionalist. "Traditions are simple, conditions were complex; and to get into the records is to get away from the stereotypes. It is from the records and with a sense of the personal equation that I have sought to speak."[5]

When reviewing *Life and Labor*, critics praised Phillips's artistry, his ability to penetrate the warp and woof of things southern, and the range of his documentation. The book, North Carolina journalist David Rankin Barbee wrote, was "the first volume of what is to be the most ambitious literary work yet undertaken by a Southern writer." It was a masterpiece. "His colors come from everywhere. His completed picture is a work of art fit to hang in any gallery."[6] Duke University historian Richard H. Shryock adopted the same metaphor, describing Phillips's portrait of plantation life in the Old South as "more authentic and more comprehensive than anything the artists have to offer. Even his style would bear comparison; for it is marked by such literary finish and such an urbanity of manner as is rarely realized by the modern historian."[7] The Kentucky poet and prose writer Allen Tate shared these sentiments. He considered *Life and Labor* "one of the most distinguished additions to the new history, and in its particular field it is without an equal." "Professor Phillips shows us, without trying, the astonishing interwoven homogeneity of southern society, in which all interests were bound up into a whole—an answer to the economists who have wondered why the poor whites followed Lee as faithfully as the rich, when they had no interest in the 'rich man's war and the poor man's fight.'" Tate supposed that Phillips also judged the antebellum planter a more appealing type than "the business pirate of today."[8]

The discovery by the authors of this book of a hitherto unknown cache of lantern slides and photographs taken and/or collected by Phillips adds new meaning to his importance as historian, empiricist, and observer of his beloved South. In collecting and marshaling photographs as sources, Phillips utilized what was for him and his peers the most modern of technologies. Photographic images enabled him to capture visually and to represent what he wanted to say about the southern past. They signified for him a natural extension of his lifelong obsession with documenting it.

But how are we to understand the images Phillips saved or collected and then used to illustrate his public lectures and his landmark *Life and Labor*? What is their value given that Phillips employed them to advance interpretations and conclusions that we reject as "racist" and "paternalistic"?

As generations of critics have underscored, Phillips had a deep and consistent attachment to the Old South and its ideals, especially to white supremacy and black inferiority. In 1909 he matter-of-factly characterized African Americans as possessing "peculiar conditions and special needs" that made the South historically separate and apart from the rest of the nation.[9] In his watershed book *American Negro Slavery: A Survey of the Supply, Employment and Control of Negro Labor as Determined by the Plantation Régime* (1918), Phillips wrote: "On the whole the plantations were the best schools yet invented for the mass training of that sort of inert and backward people which the bulk of the American negroes represented."[10] In *Life and Labor* he noted that "the bulk of the black personnel was notoriously primitive, uncouth, improvident and inconstant, merely because they were Negroes of the time; and by their slave status they were relieved from the pressure of want and debarred from any full-force incentive of gain." Phillips maintained that southern black people, like children, "were more or less contentedly slaves, with grievances from time to time but not ambition. With 'hazy pasts and reckless futures,' they lived each moment as it flew, and left 'Old Massa' to take such thought as the morrow might need."[11] Though from all reports Phillips treated persons of color kindly and respectfully, he punctuated his scholarship with casual references to "darkies" and "pickaninnies."[12]

His newly discovered photographic archive revives many of the contentious questions that swirl around the bigger meaning of Phillips's writings and his place as a leading American historian and writer. These are important questions. They frame both the photographs and subject of this book.

ULRICH BONNELL PHILLIPS was born in the small west Georgia town of La Grange on November 4, 1877. His father was of yeoman stock but his mother, whom Phillips considered his foremost inspiration, had a plantation background. Phillips attended the Tulane Preparatory School in New Orleans before entering the University of Georgia, where he earned a bachelor's degree in 1897 and a master's degree two years later. Phillips attended the 1898 summer term at the University of Chicago, where he fortuitously took classes with historian Frederick Jackson Turner. Researching political parties in antebellum Georgia, Phillips embraced Turner's economic determinism and regionalism, his vision of the frontier as a "process," and the western historian's insights into American sectionalism. Phillips always considered Turner his mentor and inspiration, even though he completed his doctorate at Columbia University in 1902 under the tutelage of William A. Dunning. At Columbia, Phillips broadened his intellectual horizons, gaining exposure to political scientist John W. Burgess's neo-Hegelianism and historian James Harvey Robinson's "New History," incorporating the broad scope of the human past, not just military and political events.[13]

Phillips's early research and writing reflected Turner's emphasis on the influence of geographical sectionalism in determining social, cultural, and political development. For

example in one of his lectures, "Plantation Architecture," Phillips revealed both his deep appreciation for the symbolic meaning of the built environment and for Turner's concept of a moving frontier. "When Virginians moved away to N.C. or Kentucky," Phillips explained, "they built homes upon the plans of those which they had admired in Virginia. When they moved further away, to the new country in Ga., Ala., Miss. or Mo., they still carried with them their Va. ideals." Commenting on the ubiquity of white-columned houses with porticos and verandahs across the South, Phillips remarked that this style "suits (our country), the Southern climate admirably and is an expression of the genius of (our) the Southern people. It is a pleasure to see it hold its own, and more, in the field against all competitors."[14]

Phillips's published dissertation, *Georgia and State Rights* (1902), explores political sectionalism in antebellum Georgia. Essentially a work of political economy and geography, the book charts the development of factions, influential families, and political groups across antebellum Georgia and politicians' positions on state, regional, and federal questions. The book unveils the impact of class conflict and economic determinism on Phillips's thought.[15] In 1901 his dissertation won the American Historical Association's Justin Winsor Prize for the best unpublished work by a promising scholar in the history of the Western hemisphere.

From 1902 to 1908 Phillips taught at the University of Wisconsin. where he joined a team of scholars, including Turner and Carl Russell Fish, teaching regional history. In these years Phillips published widely, including the path breaking *History of Transportation in the Eastern Cotton Belt to 1860* (1908). Phillips also immersed himself in studying and compiling data on the economic history of slavery. In a draft proposal for a projected three-volume "Economic History of Negro Slavery in North America" (to be coauthored with the Wisconsin Progressive and political scientist Charles McCarthy), Phillips sketched out the topics that preoccupied him and dominated his research for the next decade and a half.[16] In July 1905 Phillips reported to McCarthy from Milledgeville, Georgia, that he was "collecting some tip top material on things in general."[17]

Influenced by McCarthy and others, during his years in Madison, Phillips also labored in the cause of Progressive reform, publishing widely in popular magazines, scholarly journals, and newspapers. An activist for an economically independent, "modern" New South, he urged white southerners to diversify their crops, limit acreage devoted to cotton planting, practice economics of scale, discourage sharecropping, and introduce "scientific" management of labor.

Phillips believed that the chief virtue of the old plantation system was its concentrating and ordering unskilled labor. He regretted that the post–Civil War's patchwork-quilt system of tenant farms fell short of this economic ideal. In 1904 Phillips published a heavily illustrated article in the *World's Work* celebrating the gradual triumph of "modern" agricultural methods in the South that were "supplanting the shiftless systems of agriculture

that rose on the ruin of slavery." Critical of black laborers as generally lazy and hence unproductive, he characterized them as "good, bad, and indifferent—mostly indifferent." Progressive planters, however, were "doing a sort of social settlement work in molding the Negroes into a greater fitness for membership in a complex civilization . . . to build up a prosperous South."[18]

Phillips's scholarly reputation rose quickly based on the number and quality of his publications during his tenure at Wisconsin. As a result, in 1908 he received a full professorship at Tulane University in New Orleans, where he unearthed large volumes of plantation documents, census data, and other primary sources. These formed the basis of his two-volume documentary edition *Plantation and Frontier, 1649–1863* (1909), a rich compendium of excerpts from planters' diaries, travelers' journals, and merchants' account books. Alfred Holt Stone, an influential Mississippi planter, economist, and Phillips's friend, extolled *Plantation and Frontier* as "an event of first importance to students of American history and economics." He praised the collection for illustrating "the economic inertia of the plantation system," in both Old and New Souths, and for providing a "corrective" to false representations of the Old South by chauvinists on both sides of the Mason-Dixon Line.[19] As Phillips emerged as the nation's foremost historian of the South, in 1911 the University of Michigan hired him away from Tulane.

Phillips taught in Ann Arbor from 1911 to 1929. At Michigan he trained such historians as Gilbert Hobbs Barnes, Dwight L. Dumond, Fred Landon, and Wendell Holmes Stephenson—scholars who made their own important contributions to the study of abolitionism, slavery, and southern history. His tenure at Michigan proved to be Phillips's most productive period not only as a teacher, but in terms of scholarship, influence, and his emergence as a writer of national renown.

In 1913 Phillips published two books—*The Life of Robert Toombs* and *The Correspondence of Robert Toombs, Alexander H. Stephens, and Howell Cobb* (which he edited for the American Historical Association). During these years Phillips also contributed important article-length studies on comparative systems of slavery, the economics of slavery, and slave crime. Phillips's most significant essay written during these years, however, "The Central Theme of Southern History," appeared in 1928 in the *American Historical Review*. According to Phillips, throughout southern history one theme solidified whites of all classes: their determination to control blacks. "Whether expressed with the frenzy of a demagogue or maintained with a patrician's quietude," the core value of southerners was "a common resolve, indomitably maintained," that the South "shall be and remain a white man's country."[20]

In his article Phillips argued that white supremacy, not slavery, constituted southern history's "central theme." Their focused purpose of maintaining racial control over blacks, Phillips said, explained white southerners' retention of an unprofitable labor system, slavery.[21] Historian Paul Gaston recalled that, as late as 1957, when he joined the University

of Virginia's history faculty, Phillips's view of slavery as a civilizing force and his famous "Central Theme of Southern History" thesis still held sway in high school and history textbooks.[22]

Even more than his "central theme" essay, Phillips's comprehensive *American Negro Slavery* (1918) established him during the 1920s as the nation's preeminent authority on slavery and the Old South. This book immediately became a key text in the literature of African American slavery. Whereas Phillips's predecessors, notably history graduate students at the Johns Hopkins University, had published narrow, institutional state studies on slavery, Phillips's volume analyzed systematically the institution of slavery as it existed in the entire South. His book surpassed in scope and detail all prior works on the subject and foreshadowed all subsequent works on slavery. More than any previous writer, Phillips recognized the complex nature of the "peculiar institution." Alone among the many authors to investigate slavery since emancipation, he sensed the importance of portraying enslavement in its broadest institutional features.

Phillips judged slavery first as a system of racial and social control, second as a training school from which the "students" never graduated, and third as an inefficient labor system. In fact, after years of poring over slave price data, plantation expense ledgers, and patterns of soil exhaustion, he concluded that maintaining slaves generally was economically unprofitable. It bound the region's precious capital, discouraged diversification of the South's industries, slowed the mechanization of southern agriculture, locked white southerners into employing a premodern mode of labor, and ensnared planters into periods of boom and bust speculation over land and slaves. Beyond these points Phillips also complained that slavery as an economic and social system discriminated against nonslaveholders, discouraged immigrants from settling in the South, and even limited freedom of speech.[23] In Phillips's opinion, "Plantation slavery had in strictly business aspects at least as many drawbacks as it had attractions. But in the large it was less a business than a life; it made fewer fortunes than it made men."[24] He proposed that, had the Civil War not intervened, slavery would most likely have died a peaceful death. Soil exhaustion and the paucity of land for the expansion of cotton cultivation would have killed it.

Phillips considered the end of slavery a mixed blessing. On the one hand it liberated southern capitalists from tying up sparse capital in chattel property and added degrees of flexibility to the southern workforce. But emancipation loosened the plantation discipline that Phillips so admired, led to the dispersion of African American agricultural laborers that kept labor scarce and untrained, and opened up a Pandora's box of racial conflict and tension.

American Negro Slavery received wide critical acclaim. Philip Alexander Bruce, a pioneer historian of slavery in Virginia, judged *American Negro Slavery* a landmark—"a monument of research, and equally so of fair and discriminating presentation." Unable to foresee future contentious scholarly debate over the history and meaning of African American slavery, Bruce informed Phillips, "I venture to say that you have said the final

word."[25] A South Carolina journalist praised the book's human interest flavor, its "historic and economic quality without departing from the method of the scientific investigator."[26]

Indeed the success of *American Negro Slavery* transformed Phillips into his generation's foremost authority on African American slavery. In 1926 Universal Pictures solicited Phillips's advice when producing its film version of *Uncle Tom's Cabin* (1927). The filmmaker sought information on such detailed aspects of slavery as the interior of the New Orleans slave market, the kind of manacles slaves wore, and slave furniture and cooking utensils.[27]

Despite *American Negro Slavery*'s importance, Phillips's *Life and Labor* became his best-known, best-selling work. It received Little, Brown and Company's $2,500 prize for the best unpublished manuscript in American history for 1928. A poll among historians ranked Phillips's book seventh among preferred works in American history published in the period 1920–1935.[28] In *Life and Labor* Phillips sketched the role of climate, physiography, and topography in shaping life along the South's expanding frontier. Dixie's weather and its soil, Phillips wrote almost deterministically, "fostered the cultivation of the staple crops, which promoted the plantation system, which brought the importation of negroes, which not only gave rise to chattel slavery but created a lasting race problem."[29]

Phillips went on to chronicle the lives of southerners, white and black, rich and poor, in the countryside, in towns, and in the hills from Virginia to Texas. Exhibiting his fascination with historic buildings as cultural artifacts, he described their homes and habits from the Tidewater across the Appalachians to the Bluegrass down the Mississippi River to the Gulf. Phillips detailed the labor of planters, gentry, overseers, slaves, free black people, white yeomen, and "crackers." Writing for general readers, not professors, Phillips incisively captured what he termed "the conditions of life"—how everyday southerners lived and worked over time and place. Seemingly nothing—the sights, sounds, smells, and flavors of the Old South—escaped his observation and commentary.[30]

Generally Phillips's analysis of slavery and plantation life in *Life and Labor* closely paralleled that of his *American Negro Slavery*. In this respect historian Wood Gray was correct in arguing that *Life and Labor* was a "popularization" of Phillips's earlier book, "with a greater attention to vivacity of tone and deftness of style."[31] In the decade since publishing *American Negro Slavery*, Phillips exhibited no major change in his attitudes toward black people. He continued to define slavery as a much-needed school for African Americans, an institution that taught "less by precept than by example." Phillips believed that the white household, much like the "social settlement" houses in the urban slums of his day, provided "models of speech and conduct, along with advice on occasion, which the vicinage is invited to accept." Slavery, "like other schools, was conditioned by the nature and habituations of its teachers and pupils. Its instruction was inevitably slow; and the effect of its discipline was restricted by the fact that even its aptest pupils had no diploma in prospect which would send them forth to fend for themselves."[32]

While Phillips considered slavery a school, he perceived the plantation as more than a schoolhouse. It assumed many social roles—as "a matrimonial bureau, something of a harem perhaps, a copious nursery, and a divorce court." Plantations also had an industrial component, serving as "a factory, in which robust laborers were essential to profits. Its mere maintenance as a going concern required the proprietor to sustain the strength and safeguard the health of his operatives and of their children, who were also his, destined in time to take their parents' places." Perhaps recalling his World War I service with and observations of segregated black enlistees at Camp Gordon, a training camp near Atlanta, Phillips likened the corps of slave laborers to "a conscript army, living in barracks and on constant 'fatigue.' Husbands and wives were comrades in service under an authority as complete as the commanding personnel could wish." Though slavery regimented the black workforce, the plantation, in Phillips's opinion, served as "a homestead, isolated, permanent and peopled by a social group with a common interest in achieving and maintaining social order. Its régime was shaped by the customary human forces, interchange of ideas and coadaptation of conduct."[33]

While Phillips had argued these points before, in *Life and Labor* he also presented a more realistic, more critical view of slavery; he even exhibited degrees of sympathy for the bondmen and women and acknowledged pathos in their lives. This signified a major break with the past in the historian's thinking about slavery.

Africans, Phillips explained for the first time, had diverse backgrounds and cultures. He credited them, for example, with developing "high artistry in sculpture" and with contributing "notable inventions." Whereas in *American Negro Slavery* Phillips virtually ignored the human condition of those Africans transported to America, in *Life and Labor* he recognized them as "victims" and empathized with "their misery and bewilderment." The Africans "were crowded into 'tween-decks too low to permit standing, lodged upon bare boards, stifled in tropical heat, sometimes afflicted with infectious disease, and always at the mercy of brutal and lustful men." Phillips estimated that more than one-half of those transported to North America died within three or four years of their captivity.[34]

After almost three decades of portraying slavery sympathetically, in *Life and Labor* Phillips described the "peculiar institution" as an exploitative system. Slavery, Phillips admitted, was premised on harsh laws and "cruelties," including coerced slave breeding and the forced concubinage of slave women to planters, their sons, and overseers. For the first time Phillips expressed moral outrage at a system under which "the rape of a female slave was not a crime, but a mere trespass upon the master's property!" "The Africans were thralls," he explained, "wanted only for their brawn, required to take things as they found them and to do as they were told, coerced into self-obliterating humility, and encouraged to respond only to the teachings and preaching of their masters, and adapt themselves to the white men's ways."[35]

Having laid bare some of slavery's barbarities, Phillips nonetheless retreated, arguing that because slavery was an institution that involved humans, the "personal equation"

defined its day-to-day operation. Slavery's mildness or severity depended on the whims of individual masters. "All in all," Phillips concluded, "the slave régime was a curious blend of force and concession, of arbitrary disposal by the master and self-direction by the slave, of tyranny and benevolence, of antipathy and affection."[36]

Though Phillips admitted that slavery took hold in the seventeenth and eighteenth centuries as a system of "crass exploitation," he was amazed that no one could have predicted "that kindliness would grow as a flower from a soil so foul, that slaves would come to be cherished not only as property of high value but as loving if lowly friends." Phillips exhibited similar condescension toward antebellum free blacks, dismissing them as at best a "complication" in the Old South's racial hierarchy. "Originating nothing," he said, "they complied in all things that they might live as a third element in a system planned for two." Phillips also denied that black Americans retained "Africanisms"—cultural links to their African background. "Thanks . . . to plantation discipline and to the necessity of learning the master's language," he wrote, "African mental furnishings faded even among adult arrivals." And Phillips joined most white scholars of his day in questioning the value of slave testimony as sources for the writing of the history of slavery. In his opinion, "ex-slave narratives in general . . . were issued with so much abolitionist editing that as a class their authority is doubtful."[37]

Life and Labor enjoyed an even more enthusiastic reception from critics than *American Negro Slavery* had. Joseph G. de Roulhac Hamilton of the University of North Carolina raved, describing that book's publication as "a real event in American historiography."[38] Because of its broad portrait of southern culture, Allen Tate judged *Life and Labor* a prime example of James Harvey Robinson's "New History."[39] New York University's Henry Steele Commager spoke for many of his fellow historians of the interwar years when he proclaimed Phillips's *Life and Labor* "perhaps the most significant contribution to the history of the Old South in this generation."[40]

Phillips's *Life and Labor* brought him professional acclaim and new opportunities. Yale University's Department of History noted Phillips's burgeoning stature and in 1929 offered what the historian termed "a flossy job" and recruited him away from Michigan.[41] Before joining the Yale faculty, however, Phillips received yet more good news; he received a year-long fellowship to study plantation societies around the globe from the Albert Kahn Foundation; "1929 is a year of grace indeed," Phillips wrote his new Yale colleague, historian Wallace Notestein.[42]

Within months, however, Phillips received a devastating jolt. Surgeons diagnosed that he had cancer of the neck and stomach. Phillips wrote his friend Herbert A. Kellar that "my projects for the near future are all now knocked galley west by an order to undergo a serious operation on my neck."[43] Despite the grim news that his cancer was inoperable, Phillips nonetheless moved ahead with his work. "Reinforced by the complete absence of perceptible symptoms," he informed Notestein, "this fool's paradise proves rather comfortable; and my emotional upset is quite ended."[44]

Phillips tried tirelessly but unsuccessfully to complete the second volume of his proposed multivolume history of the South. He died on January 21, 1934, at age fifty-six. As a tribute to Phillips, in 1939 the American Historical Association published his unrevised chapters along with "The Central Theme of Southern History" in one volume as *The Course of the South to Secession: An Interpretation*, edited by University of Georgia historian E. Merton Coulter.[45]

MUCH OF PHILLIPS'S REPUTATION as a historian rests on his constructing his scholarship atop a sturdy foundation of hitherto unknown research materials. Unlike previous historians of slavery, he considered legal texts too one-sided and instead employed newspapers and a broad range of plantation materials—diaries, ledgers, letters, and reminiscences—to document slavery and southern history. These sources enabled Phillips to delve into the "new" social and economic history that he first encountered as a student at Columbia.

In addition to identifying and establishing southern history and African American slavery as serious research fields, Phillips also played an influential role in locating primary source materials necessary for his work. Much of this was "self-archival" work because large manuscript collections of southern Americana such as the Southern Historical Collection at the University of North Carolina at Chapel Hill and Duke University's Manuscript Department had not yet been established. Early in the twentieth century, Phillips led the way in urging southerners to collect archival sources pertaining to their region, especially plantation-generated manuscripts, and in making the case for their preservation. Drawing on his personal contacts and connections in his native South, Phillips became a crusader for the establishment and funding of southern research libraries and archives.

"The history of the United States," he explained early in his career, "has been written by Boston and largely written wrong. It must be written anew before it reaches its final form of truth, and for that work the South must do its part in preparation. New England has already over-done its part. . . . A study of the conditions of the Old South from the inside readily shows an immense number of errors of interpretation by the old school of historians. . . . What must be sought is the absolute truth, whether creditable or not."[46] A year later Phillips used similar language to make much the same point. "The history of the South," he wrote in a grant application, "is to be studied in a scientific spirit, and from the inside."[47] Phillips meant that by utilizing southern sources he and fellow scholars could write an accurate, objective history of his region.

In 1913 Phillips complained to Gamaliel Bradford, the popular Boston biographer, that "standard American historians have never taken the immense pains which would be necessary for grasping the social conditions and problems prevalent in the antebellum South and in their ignorance of these they have, whether consciously or not, imputed perversity as the source of the distinctively Southern policies in politics. Southerners have themselves been at fault in neglecting to publish data which would promote the correction

of this."[48] Determined to remedy this problem, during his relatively short career, Phillips took "immense pains," asking original questions about southern economic and social history, systematically gathering and researching the records of the South, and crafting eloquent prose to explain what he often described as the riddles of southern life and culture. In doing so Phillips distinguished himself as one of the leading figures of southern historiography and established southern history as a rigorous and serious research field.

Over time Phillips also became an avid collector of manuscript materials, employing them as research tools in his many publications and enjoying the quest of hunting for and locating old documents in barns, corncribs, and outbuildings across the South. Phillips admired and envied Wymberley Jones De Renne's private collection at Wormsloe Plantation near Savannah. In 1932 Phillips praised De Renne for "erecting a fire-proof temple under the moss-draped liveoaks to house his treasures. To his two tables, the one enriched from an ancestral cellar of sherries and madeiras, the other laden at command with manuscripts and rare pamphlets, he welcomed friends and students, as I can warmly testify."[49] By the 1920s Phillips had become a dealer of sorts in rare southern library materials, selling (at significant profit to himself) and trading library materials to friends, private collectors, and institutions.[50]

Perhaps as a natural extension of his interest in manuscript and library materials, Phillips also pioneered the editing and publishing of texts and documentary histories based on his archival discoveries. Phillips's *Plantation and Frontier*, for example, constituted the first and remains one of the most comprehensive collections of documents on the Old South. It included 386 documents, 104 of which he culled from fifty-five private manuscript collections and forty-nine public libraries and archives.[51] In 1961 historian Fletcher Green heaped praise on Phillips's documentary edition, describing it as "the most important single collection of published source documents on the plantation regime of the pre–Civil War South."[52] Phillips, then, not only delineated many of the themes and topics that later generations of historians of southern history and slavery would study, but he also helped to locate, preserve, and disseminate the primary sources necessary to document the region's complex history. To a significant degree, Phillips was an intellectual middleman—an intermediary between the primary sources of the South and the public.[53]

THOUGH PHILLIPS RANKED as the foremost historian of the South until the 1950s, not surprisingly some of his contemporaries sharply criticized him. Frederic Bancroft, William M. Brewer, W. E. B. Du Bois, Mary White Ovington, Charles H. Wesley, Carter G. Woodson, and others upbraided Phillips for his proslavery interpretation generally and for his condescension, detachment, insensitivity, and patronizing tone when describing people of color. In the post–World War II period, as the civil rights movement slowly overturned segregation and positioned "race" in the forefront of Americans' consciousness, historians lined up to attack Phillips. The Marxist scholar Herbert Aptheker, and two mainstream academics, Richard Hofstadter and Kenneth M. Stampp, became Phillips's

most outspoken critics.[54] Of the three historians, Aptheker's attacks on Phillips were the most personal, pointed, and polemical.

In 1956 Aptheker observed that Phillips's famous "central theme" thesis signified "the axis around which revolves Southern history." He added, however, that while other scholars employed the "central theme" thesis theoretically to interpret the southern past, Phillips viewed it "with great sympathy; he was, in fact, its ardent supporter."[55] Phillips's "moonlight-and-magnolia mythology concerning the ante-bellum South," Aptheker remarked a year later, established Phillips as "its academic standard bearer."[56] In 1969 Aptheker denounced Phillips as "a devout white supremacist who was as incapable of writing truthfully of what it meant to be a Negro slave . . . as it would have been for Joseph Goebbels to have written truthfully of what it meant to be a Jew."[57]

Even after the formal civil rights campaigns had ended, Aptheker continued to hammer away at Phillips. He considered Phillips's scholarship dangerous, reactionary, and unfortunately still too influential. In 1977 Aptheker took aim at those scholars, including historian Gerald W. Mullin and presumably Eugene D. Genovese, who emphasized slavery's "allegedly patriarchal nature." Aptheker judged analyses by historians regarding the so-called reciprocal relations between masters and slaves, "in keeping with the Phillipsian and neo-Phillipsian school. U. B. Phillips was not only blatantly racist," Aptheker charged, but "he was also clearly wrong in his total picture of what it meant to be a slave in the United States." Aptheker went on to allege: "The newer Phillipsians certainly are less racist—at least in language—but their depiction of the realities of slavery in the United States reflects the moonlight-molasses-magnolia mythology of both Phillips and 'Gone with the Wind.'"[58]

In 2002, a year before his death, Aptheker made clear that revising Phillips's biased writings on slavery had shaped his scholarly agenda since graduate school. *American Negro Slavery*, Aptheker recalled, "was the standard text that we all used" when he studied at Columbia in the 1930s and 1940s. "It is a chauvinistic work, filled with ideas of the docility and passivity of the Negro in the United States, unlike the Negro in Jamaica and Haiti. This was nonsense but was very influential and very important in the United States at the time. Correcting his errors would be something I would devote myself to." Aptheker went on to charge that "Phillips falsified the whole subject" of slavery. He explained that in 1943 he had deliberately titled his *American Negro Slave Revolts* to rebut the title of Phillips's classic *American Negro Slavery*.[59]

Today, when historians mention Phillips, they generally categorize him in 1960s terms as the archetypical white supremacist historian of slavery. Condemning him as a racist and accusing him of Negrophobia, most historians since World War II, with a few notable exceptions, have condemned Phillips and his work. They dismiss Phillips because of his Jim Crow—era view of African Americans as biologically and culturally inferior to whites, his defense of slavery as a "civilizing" school for blacks, his insensitivity to African

American culture, his identification with the South's gentry class, and his idealization and celebration of southern exceptionalism.

The influential historiographer Peter Novick has gone so far as to assert that on the matter of racial control as a determinant in social relations, Phillips personally practiced what he preached. "Phillips's books went beyond a 'sympathetic treatment' of slavery," Novick wrote, "they all but recommended it."[60] Merton L. Dillon, one of Phillips's biographers, diagnosed accurately Phillips's reputation as an authority on slavery as the end of the twentieth century neared. "Exposure to Ulrich B. Phillips's once respected studies of slavery," Dillon quipped, "now are routinely preceded by Surgeon General–like warnings of racist contaminants of which earlier readers were unaware."[61]

DESPITE CURRENT HISTORIANS' TENDENCY to denigrate him as a racist and a relic of the Jim Crow–era South, Phillips matters precisely because his pioneer work provides a clear window into early-twentieth-century understandings of slavery, race, and the essence of southern history. His nine books, most notably *American Negro Slavery* and *Life and Labor*, and more than fifty-five articles mark Phillips as the most thorough, systematic, and resourceful student of antebellum southern economic and social history of his generation and beyond.[62] Few scholars have left as wide and deep an imprint on the field of southern history and mythology as Phillips.

He was the first historian to study African American slavery systematically and in its whole—from the colonial period through the antebellum era—and the Old South's slaveholding elite. Phillips led historians of his day in focusing minutely and analytically on the economics of slavery, especially the institution's long- and short-term profitability. He constructed a complex interpretation of the antebellum South as an organic society with slavery at its center and the plantation as its outer structure. It was populated by docile slaves and kindly, patriarchal masters. Phillips insisted that slaves were inefficient laborers and slavery was generally unprofitable to masters. Phillips in fact insisted that planters could have garnered higher yields by capitalizing other commodities.

Nonetheless, to Phillips's mind, slavery proved an essential mode of social and racial control, of order and discipline, between what he deemed interdependent unequals—masters and slaves. Considerable give-and-take between master and slave characterized slavery, Phillips said. It served as a benevolent, "civilizing" force for backward African Americans, even though it burdened southerners financially and politically. While acknowledging cases of slave unrest, even revolt, Phillips insisted that race relations in the Old South were generally harmonious.[63]

Long after slavery's demise, as historian Darden Asbury Pyron observed, Phillips yearned for the simpler racial dynamic of the "peculiar institution" and the "plantation régime." Pyron wrote: "Without any suspicion of Black integrity, Black autonomy, or Black culture," Phillips "celebrated the objectives of racial segregation, control, and domination.

He went so far as to consider planter methods an appropriate and efficient model even for twentieth-century industrial society in the region."[64] "For him," Phillips wrote in 1918, "who has known the considerate and cordial, courteous and charming men and women, white and black, which that picturesque life in it best phases produced, it is impossible to agree that its basis and its operation were wholly evil, the law and the prophets to the contrary notwithstanding."[65]

Despite his conservative, romanticized interpretation of the Old South, Phillips has nonetheless retained a persistent hold on historians' imaginations and analyses since his death in 1934. Historian John W. Blassingame remarked in 1978 that "the ghost of U. B. Phillips haunts all of us."[66] Even Kenneth M. Stampp, one of Phillips's most influential critics, observed in 1976: "In their day the writings of Ulrich B. Phillips on slavery were both highly original and decidedly revisionist."[67] Phillips's works were "revisionist," Stampp explained four years later, because they "portrayed the institution [of slavery] as, in the main, benevolent and a civilizing force which did much good for the blacks at little cost to them." Slavery and the plantation system "aroused" in Phillips "not ethical concerns but nostalgia."[68] In 1982 Stampp went so far as to inform members of the Southern Historical Association that Phillips "was about as objective as the rest of us, and that's not very much."[69] That same year, assessing recent scholarship on slavery, historian Willie Lee Rose noted a revisionist trend that recast elements of Phillips's celebration of plantation paternalism. This was less "political reaction," she explained, but more "the product of real work in the archives and a more complete absorption of the realities of human nature at work even in a slave society. U. B. Phillips has not arisen from the grave. We have survived the realization that even he may have done some things right."[70]

Expanding on these insights into Phillips's importance, in 1993 historian Daniel C. Littlefield praised Phillips's "original and careful research," his "penetrating intelligence," and his "literary felicity." Phillips dominated the historiography of slavery for almost four decades, Littlefield argued, "because his objectionable racism was an expression and representative of prevailing American opinion shared even by some who rejected his apologetics." Littlefield noted that Phillips considered himself a detached, objective "scientific" historian, one who wrote history impartially and without the partisanship of the old abolitionists or proslavery apologists. "That he was a Southerner with strong feelings for the South he would proudly admit. That he was a white supremacist with a firm belief in black inferiority he would publically aver. He did not seem to think, nor did others of his generation, that such conditioning affected his judgments. In a period of segregation and full-throated Anglo-Saxonism, his was the majority opinion."[71]

AS LITTLEFIELD OBSERVED, Phillips wrote and dominated the field of southern history at a time when racism clouded the vision of almost all white scholars, preventing them from seeing clearly slavery's brutalities, injustices, and the legacies of discrimination and hate it engendered. Phillips's many critics correctly have identified him as a symbol of

a historiography wedded to defending the Old South and southern mores. Phillips unabashedly argued the case of the Old South while working to reform the New South. According to historian Daniel Joseph Singal, as Philips matured, he became more conservative on race and more strident in his defense of his region. He was "southern post-Victorian," and his "position on race hardened into a stern defense of the iron hand of segregation, while traditional southern mythology occupied a larger and larger place in his work."[72]

To be sure, Phillips was a product of his background, time, and place. He subscribed fully to the white supremacist ideology of the Jim Crow era, but probably because of his background, education, refinement, and membership in the professoriate, he shunned practicing overt racism. Singal insists that Phillips was no "bigoted Old South Bourbon bent on resurrecting slavery." Rather his racism "was no more or less than the standard fare of his time. In fact, when compared to his fellow southerners in this respect, Phillips comes out looking much like a reformer."[73]

To dismiss Phillips totally for his racist caricatures and conservative interpretations is to violate one of the cherished principles of the historian's craft—to evaluate events, people, and subjects within context. Historians who denounce Phillips, especially without reading his oeuvre, need to shed contemporary belief systems and slip into the mindset of his day. Phillips's groundbreaking publications on the economics of slavery and the plantation system stood largely uncontested for decades and set the scene for Stampp's major revisionist work in the 1950s. Phillips's writings remain important and hold a central place in the historiography of slavery and the South. "Writing history for publication in print creates," historian Rhys Isaac reminds us, "a problematic artefact, the unchanging product of a past time when a yet earlier past time was self-consciously revisited and reported on in writing."[74] "Hindsight History," historian Joseph J. Ellis has written recently, "is usually not history at all, but most often a condescending game of one-upmanship in which the living play political tricks on the dead, who are not around to defend themselves."[75]

From our comfortable historical and political distance, Phillips might seem like an unlikely candidate around whom to publish a collection of photographs documenting race, place, and the New South. Yet Phillips's photographs, eighty-seven of which are published here for the first time, document more than his condescending and patronizing views of African Americans. They also capture the persons of his day where they lived and worked. Phillips's photographs tell us much about his obsession with documenting and interpreting the South's past and the construction of its historical memory. Just as Phillips systematically gathered plantation records and holograph letters from across the region, he also acquired visual representations of the built environments, landscapes, and peoples about whom he wrote.

Phillips's photographic archive provides unusual access into that historian's thought process. The images allow us to learn what he consciously decided to record for his historical memory and what he considered representative and/or unusual about the land he

loved. Phillips's photographs provide tantalizing clues as to what these images might have meant to him, how he used them for his teaching and writing, and the degree to which they reinforced or altered his personal memories of the South of his youth in post-Reconstruction Georgia and his young adulthood in the first New South.

To what extent did Phillips ponder the stories behind the photographs he took or purchased? To what degree did he consider the "mute testimony" that scholars and scientists of Phillips's day judged useful in "reading" human subjects for indicators of intelligence and or character?[76] Did Phillips overcome the epistemological difficulties that we encounter when using images to write history?[77]

To an important extent Phillips considered these images "documents" as much as the paper records, books, and artifacts that he uncovered in dusty attics, damp basements, chicken coops, and courthouses across the South. His photographs document and help us understand life and labor in the New South, the region's social and economic conditions, its aesthetics, its built environment, its visual culture, and, yes, its color line.

NOTES

1. Ulrich Bonnell Phillips, *Life and Labor in the Old South* (New York: Grosset & Dunlap, 1929). This edition appeared by arrangement with the original publisher, Little, Brown and Company.

2. Ibid., 342.

3. See John Herbert Roper, "A Case of Forgotten Identity: Ulrich B. Phillips as a Young Progressive," *Georgia Historical Quarterly* 60 (Summer 1976): 165–75.

4. See John David Smith, "'Keep 'em in a fire-proof vault'—Pioneer Southern Historians Discover Plantation Records," *South Atlantic Quarterly* 78 (Summer 1979): 376–91, and John David Smith, "The Historian as Archival Advocate: Ulrich Bonnell Phillips and the Records of Georgia and the South," *American Archivist* 52 (Summer 1989): 320–31.

5. Phillips, *Life and Labor in the Old South,* vii–viii.

6. David Rankin Barbee, "The Old South Interpreted Anew," *Baltimore Sun Magazine,* July 7, 1929, 1.

7. Richard H. Shryock, review of Ulrich B. Phillips, *Life and Labor in the Old South, South Atlantic Quarterly* 29 (January 1930): 95.

8. Allen Tate, "Life in the Old South," review of *Life and Labor in the Old South, New Republic* 59 (July 10, 1929): 211–12.

9. Ulrich Bonnell Phillips, "Georgia in the Federal Union, 1776–1861," in *The South in the Building of the Nation,* 12 vols. (Richmond: Southern Historical Publication Society, 1909), 2:167.

10. Ulrich Bonnell Phillips, *American Negro Slavery: A Survey of the Supply, Employment and Control of Negro Labor as Determined by the Plantation Régime* (New York: D. Appleton, 1918), 343.

11. Phillips, *Life and Labor in the Old South,* 200, 196.

12. See for example Phillips, *American Negro Slavery,* 249, 309, 323, 343; *Life and Labor in the Old South,* 174, 175.

13. There are two splendid biographies of Phillips: John Herbert Roper, *U. B. Phillips: A Southern Mind* (Macon, Ga.: Mercer University Press, 1984), and Merton L. Dillon, *Ulrich Bonnell Phillips: Historian of the Old South* (Baton Rouge: Louisiana State University Press, 1985). For an anthology of critical essays, see *Ulrich Bonnell Phillips: A Southern Historian and His Critics,* edited by John David Smith and John C. Inscoe (1990; Athens: University of Georgia Press, 1993).

14. Ulrich B. Phillips, "Plantation Architecture," unpublished manuscript, no date, Ulrich Bonnell Phillips Papers (MS397), Manuscripts and Archives, Yale University Library (hereafter cited as Phillips Papers, Yale).

15. John H. Roper, "Ulrich B. Phillips," *Dictionary of Georgia Biography*, 2 vols., edited by Kenneth Coleman and Charles Stephen Gurr (Athens: University of Georgia Press, 1983), 2:793–94.

16. Charles McCarthy and Ulrich B. Phillips, "The Economic History of Negro Slavery in North America," unpublished manuscript, no date, Phillips Papers, Yale.

17. Ulrich B. Phillips to Charles McCarthy, July 29, 1905, Charles McCarthy Papers, Wisconsin Historical Society, Madison.

18. Ulrich Bonnell Phillips, "Making Cotton Pay," *World's Work* 8 (May 1904): 4782–92.

19. Alfred Holt Stone, review of Ulrich B. Phillips, ed., *Plantation and Frontier, 1649–1863*, *American Historical Review* 16 (October 1910): 138, 139.

20. Ulrich B. Phillips, "The Central Theme of Southern History," *American Historical Review* 34 (October 1928): 30–43.

21. Ibid.

22. Paul M. Gaston, *Coming of Age in Utopia: The Odyssey of an Idea* (Montgomery: NewSouth Books, 2010), 251–52.

23. Daniel Joseph Singal, "Ulrich B. Phillips: The Old South as the New," *Journal of American History* 63 (March 1977): 886.

24. Phillips, *American Negro Slavery*, 401.

25. Philip Alexander Bruce to Ulrich B. Philips, March 11, 1919, Phillips Papers, Yale.

26. W. W. Ball to Ulrich B. Phillips, June 18, 1918, Phillips Papers, Yale.

27. B. E. Brown to Ulrich B. Phillips, August 10, 1926 (typescript copy), Ulrich B. Phillips Papers, Southern Historical Collection, University of North Carolina at Chapel Hill (hereafter cited as Phillips Papers–UNC).

28. John Walton Caughey, "Historians' Choice: Results of a Poll on Recently Published American History and Biography," *Mississippi Valley Historical Review* 39 (September 1952): 299.

29. Phillips, *Life and Labor in the Old South*, 3.

30. Ibid., vii.

31. Wood Gray, "Ulrich Bonnell Phillips," in *The Marcus W. Jernegan Essays in American Historiography*, edited by William T. Hutchinson (Chicago: University of Chicago Press, 1937), 363.

32. Phillips, *Life and Labor in the Old South*, 199, 201.

33. Ibid., 203, 197, 196.

34. Ibid., 189, 191.

35. Ibid., 204n, 214, 211, 162, 194.

36. Ibid., 216, 217.

37. Ibid., 214, 170, 172, 195, 219. Nevertheless, as early as 1909, Phillips cited four former-slave narrators (Frederick Douglass, Josiah Henson, Charles Stearns, and Austin Stewart) as authorities in his "Racial Problems, Adjustments and Disturbances," in *The South in the Building of the Nation*, 4:240–41.

38. J. G. de Roulhac Hamilton, "Interpreting the Old South," *Virginia Quarterly Review* 5 (October 1929): 631.

39. Tate, "Life in the Old South," 211.

40. Henry Steele Commager, review of Phillips, *Life and Labor in the Old South*, *New York Herald Tribune*, May 19, 1929, 4.

41. Ulrich B. Phillips to Yates Snowden, June 23, 1929, Yates Snowden Papers, South Caroliniana Library, University of South Carolina.

42. Ulrich B. Phillips to Wallace Notestein, June 14, 1929, Wallace Notestein Papers, Sterling Memorial Library, Yale University.

43. Ulrich B. Phillips to Herbert A. Kellar, November 15, 1930, Herbert A. Kellar Papers, Wisconsin Historical Society.

44. Phillips to Notestein, December 26, 1930, Notestein Papers.

45. "The Committee on the Albert J. Beveridge Fund," December 12, 1938, *Annual Report of the American Historical Association* (Washington, D.C.: U.S. Government Printing Office, 1939), 59; Ulrich Bonnell Phillips, *The Course of the South to Secession: An Interpretation*, edited by E. Merton Coulter (New York: D. Appleton-Century, 1939).

46. Ulrich B. Phillips to Lucien H. Boggs, March 26, 1903, Phillips Papers–UNC.

47. Ulrich Bonnell Phillips, "Application for a Grant in Aid of Research, to study the history of plantation slaveholding in the Antebellum South, May 28, 1904," Ulrich B. Phillips Folder, Carnegie Institution of Washington Archives, Washington, D.C.

48. Ulrich B. Phillips to Gamaliel Bradford, August 9, 1913, Gamaliel Bradford Correspondence, Houghton Library, Harvard University.

49. Ulrich Bonnell Phillips, review of *Catalogue of the Wymberley Jones De Renne Georgia Library at Wormsloe, Isle of Hope near Savannah, Georgia, American Historical Review* 38 (October 1932): 174.

50. See James G. Hollandsworth Jr., *Portrait of a Scientific Racist: Alfred Holt Stone of Mississippi* (Baton Rouge: Louisiana State University Press, 2008), 196–97.

51. See John David Smith, "Ulrich Bonnell Phillips' *Plantation and Frontier:* The Historian as Documentary Editor," *Georgia Historical Quarterly* 77 (Spring 1993): 123–44.

52. Fletcher M. Green, ed., *Ferry Hill Plantation Journal, January 4, 1838–January 15, 1839* (Chapel Hill: University of North Carolina Press, 1961), vii.

53. On the role of the historian as intermediary between sources and the public, see Alex Burghart, "The iPast," *Times Literary Supplement* (London), August 6, 2010, 22.

54. See Richard Hofstadter, "U. B. Phillips and the Plantation Legend," *Journal of Negro History* 29 (April 1944): 109–24, and Kenneth M. Stampp, "The Historian and Southern Negro Slavery," *American Historical Review* 57 (April 1952): 613–24. On Phillips's changing status among American historians, see John David Smith, "The Historiographic Rise, Fall, and Resurrection of Ulrich Bonnell Phillips," *Georgia Historical Quarterly* 65 (Autumn 1981): 138–53.

55. Herbert Aptheker, "The Central Theme of Southern History—A Re-Examination," in his *Toward Negro Freedom* (New York: New Century, 1956), 183.

56. Aptheker, "The Study of American Negro Slavery," *Science and Society* 21 (Summer 1957): 257.

57. Aptheker, "Author's Preface to the 1969 Edition," in his *American Negro Slave Revolts* (1943; reprint, New York: International Publishers, 1969), 2.

58. Aptheker, "Commentary," in *Comparative Perspectives on Slavery in New World Plantation Societies,* edited by Vera Rubin and Arthur Tuden (New York: New York Academy of Sciences, 1977), 493.

59. Aptheker, "Vindication in Speaking Truth to Power," in *Against the Odds: Scholars who Challenged Racism in the Twentieth Century,* edited by Benjamin P. Bowser and Louis Kushnick (Amherst: University of Massachusetts Press, 2002), 199–200.

60. Peter Novick, *That Noble Dream: The "Objectivity Question" and the American Historical Profession* (Cambridge: Cambridge University Press, 1988), 229.

61. Merton L. Dillon, review of C. Peter Ripley, *Witness for Freedom: African American Voices on Race, Slavery, and Emancipation, African American Review* 29 (Winter 1995): 674.

62. See Fred Landon and Everett E. Edwards, "A Bibliography of the Writings of Professor Ulrich B. Phillips," *Agricultural History* 8 (October 1934): 196–218, and David M. Potter Jr., "A

Bibliography of the Printed Writings of Ulrich Bonnell Phillips," *Georgia Historical Quarterly* 18 (September 1934): 270–82. Neither bibliography is complete.

63. For a fuller analysis of Phillips's importance as a historian of slavery and the Old South, see John David Smith, *An Old Creed for the New South: Proslavery Ideology and Historiography, 1865–1918,* third printing with a new preface (Carbondale: Southern Illinois University Press, 2008).

64. Darden Asbury Pyron, "U. B. Phillips: Biography and Scholarship," *Reviews in American History* 15 (March 1987): 73.

65. Phillips, *American Negro Slavery,* 514.

66. John W. Blassingame, "Redefining *The Slave Community:* A Response to the Critics," in *Revisiting Blassingame's "The Slave Community,"* edited by Al-Tony Gilmore (Westport, Conn.: Greenwood Press, 1978), 158.

67. Kenneth M. Stampp, "Slavery—The Historian's Burden," in *Perspectives and Irony in American Slavery,* edited by Harry P. Owens (Jackson: University Press of Mississippi, 1976), 160.

68. Kenneth M. Stampp, "The Irrepressible Conflict," in his *The Imperiled Union: Essays on the Background of the Civil War* (New York: Oxford University Press, 1980), 200.

69. Kenneth M. Stampp, comment at Southern Historical Association annual meeting, November 5, 1982, Memphis, Tennessee (notes in possession of the authors).

70. Willie Lee Rose, "The New Slave Studies: An Old Reaction or a New Maturity?" in her *Slavery and Freedom,* expanded edition, edited by William W. Freehling (New York: Oxford University Press, 1982), 200.

71. Daniel C. Littlefield, "From Phillips to Genovese: The Historiography of American Slavery before *Time on the Cross,*" in *Slavery in the Americas,* edited by Wolfgang Binder (Würzburg: Königshausen & Neumann, 1993), 1–2.

72. Singal, "Ulrich B. Phillips: The Old South as the New," 890–91.

73. Ibid., 880.

74. Rhys Isaac, "Power and Meaning: Event and Text: History and Anthropology," in *Dangerous Liaisons: Essays in Honour of Greg Dening,* Melbourne University History Monograph 19, edited by Donna Merwick (Parkville, Victoria: University of Melbourne, 1994), 299.

75. Joseph J. Ellis, *American Creation: Triumphs and Tragedies at the Founding of the Republic* (New York: Random House, 2007), 234.

76. See Mary Niall Mitchell, *Raising Freedom's Children: Black Children and Visions of the Future after Slavery* (New York: New York University Press, 2008), 64–65.

77. On the broad cultural meaning of historical photographs, especially pertaining to race, see John Tagg, *The Burden of Representation: Essays on Photographs and Histories* (Amherst: University of Massachusetts Press, 1988); Shawn Michelle Smith, *American Archives: Gender, Race, and Class in Visual Culture* (Princeton: Princeton University Press, 1999); James Allen, Hilton Als, John Lewis, and Leon F. Litwack, *Without Sanctuary: Lynching Photography in America* (Santa Fe: Twin Palms Publishers, 2000); Library of Congress, *A Small Nation of People: W. E. B. Du Bois & African American Portraits of Progress* (New York: HarperCollins for the Library of Congress, 2003); Shawn Michelle Smith, *Photography on the Color Line: W. E. B. Du Bois, Race, and Visual Culture* (Durham: Duke University Press, 2004); Michael Bieze, *Booker T. Washington and the Art of Self-Representation* (New York: Peter Lang, 2008); Molly Rogers, *Delia's Tears: Race, Science, and Photography in Nineteenth-Century America* (New Haven: Yale University Press, 2010); Mary Niall Mitchell, "Portrait or Postcard? The Controversy over a 'Rare' Photograph of Slave Children," *History News Network,* http://www.hnn.us/articles/128183 .html (accessed June 21, 2010); and Leigh Raiford, *Imprisoned in a Luminous Glare: Photography and the African American Freedom Struggle* (Chapel Hill: University of North Carolina Press, 2011).

1

"A Wooden Box . . .
Filled with Photographs and Plates"

Ulrich Bonnell Phillips's Visual Archive

"As to photographs," Ulrich Bonnell Phillips wrote in 1928, "I particularly want Gaines-wood and the several Galliers' houses, . . . of log houses I should like several specimens. . . . Meanwhile, if you could find some friend who has made a tour with a good kodak, it might be quite a stroke if I could look through his collection of views."[1] Phillips, then engaged with lining up illustrations for his forthcoming *Life and Labor in the Old South,* was responding to North Carolina journalist David Rankin Barbee, who had instructed him to "make me out an exact list of what you want and I will undertake to get them all for you, without cost if that is possible."[2] Barbee obliged Phillips's request and successfully obtained most of the images the historian sought for use in his next volume.[3]

Phillips's determination to employ photographic images to help make his points is not surprising. His earlier extensive reliance on manuscript sources—account books, diaries, letters, plantation records, and whatever other textual materials he could find—served as foundation for his distinctive interpretation of the American South. His emerging photographic archive simply comprised documents of another sort. Throughout his career Phillips strongly encouraged a growing network of friends, students, and colleagues to identify, collect, and preserve documentary and textual materials. For decades he worked again and again to create archives of southern sources so that historians could write the region's past based on documentary evidence, not conjecture, and to establish that past as a significant field of study.[4] Photographs he gathered were visual records of landscape and architecture, of the persistence and evolution of work practices, and of the diversity of the southern population. As his acquaintances searched for manuscripts and paper records to document their research, Phillips pressed them for pictures as well. Each type of source contributed to the ongoing reinterpretation of the history of the American South.

Phillips's commitment to southern Progressivism and to "scientific" history pushed him to seek documents of every kind, including photographs.[5] He formulated a theory of southern development grounded in archives, shedding light on the present and suggesting promising avenues for the future. Phillips never studied history for its own sake. Rather he drew on the past to inform solutions for present-day problems, and he always intended to use his historical expertise to engage actively with contemporary issues.[6] The empirical nature of his process and the relevance of his scholarship to present-day political issues, Phillips reasoned, lent itself to the use of photographic images.

In Phillips's opinion the rapidly advancing technology of photography provided the best way to record places, people, and objects "scientifically." And using this most modern documentary method to support his arguments gave those notions more immediacy and currency than simple prose. Phillips's photographs provided a bridge from the historical past to the problematic present. He could present artifacts (buildings and landscapes), establish continuities (plantation agriculture and labor practices), and create a documentary record to support his particular vision of how best to address challenges facing the contemporary South. Thus much of Phillips's photographic archive became anthropological in nature as he observed the culture, assembled evidence, and formulated theories about its development. Documentation of the society under study complete, Phillips could become prescriptive, offering paths to greater regional prosperity and economic success.

Phillips had been quick to embrace the new photographic technology of his day in classrooms and public lecture halls. In December 1903, Phillips wrote Thomas M. Owen, director of the Alabama Department of Archives and History, that he wanted "to read a paper upon the history of the Plantation System. If you have a stereopticon at command I would prefer to put it in the form of an illustrated lecture."[7] Four of six lectures that he delivered for the University of Wisconsin Extension Division are identified as "illustrated."[8] His biographers note that students at the University of Michigan and Yale remembered quite distinctly that Phillips "had several presentations in which he sang slave songs and showed slides that captivated any audience."[9] In January 1927 the *Galveston Daily News* reported that Phillips had delivered a lecture in the city on "the plantations of the South in ante bellum days" delivered "in a most interesting and effective manner" and "illustrated by many very interesting stereopticon pictures."[10] Phillips clearly drew on his visual collections to educate and entertain academic and public audiences. The wooden box of lantern slides and cartons of prints deposited among his papers at Yale attest to his commitment to collecting relevant images and visual materials and employing them in multiple ways.

With the notable exception of "Making Cotton Pay," an article Phillips published in the *World's Work* in 1904, visual images were rarely integrated into his early popular or scholarly writing. The eighteen photographs included in that piece—images of a plantation mansion and black sharecroppers' cabins, the picking, weighing, ginning, and baling

of cotton, and young and elderly African Americans—were inserted by the publisher and used to underscore the importance of agricultural reform. In the article Phillips implored white southerners to modernize their agriculture by "supplanting the shiftless systems of agriculture that rose on the ruins of slavery." One caption notes: "The labor problem is to induce the Negroes to desire a better standard of living." He maintained that by employing "scientific," twentieth-century management of "the Negro, the mule, the land, and the staple" and by diversifying their crops, southern planters could increase their productivity and profits. "Every progressive planter," Phillips concluded, "by setting an attractive example and by doing a sort of social settlement work in molding the Negroes into a great fitness for membership in a complex civilization, is doing his part to build up a prosperous South."[11]

Years later, in *Life and Labor in the Old South,* Phillips incorporated photographs into his scholarship. Unlike his earlier scholarly works, this book contains a significant number of illustrations from multiple sources. Twenty-two pages provide assorted maps, drawings, and photographs. Phillips's publisher, Little, Brown and Company, integrated the thirty-seven photographs into relevant chapters and accompanied each with short titles instead of grouping them together in one or two sections of the book. The volume's front matter contains extensive descriptions of the images and credits. Phillips undoubtedly intended the pictures to engage with the text and went to considerable lengths obtaining photographs that fit his needs. When reviewing *Life and Labor,* University of Chicago historian Avery O. Craven noted that "quotations and men and documents are allowed to speak so much for themselves that the impression is often that of a number of detailed snapshots skillfully arranged." Perhaps the real "snapshots skillfully arranged" reinforced this impression. Craven also considered the book to be "thoroughly objective at all times," a perception assisted by the straightforward black-and-white photographs that graced the work.[12]

Phillips took at least ten of the thirty-seven images included in *Life and Labor* himself: landscapes and a series focusing on the distinctive architectural characteristics of cabins and log housing. He obtained other views for the text from friends and acquaintances or found them among photographic postcards popular during the period.[13] In addition to David Rankin Barbee, Phillips received assistance in identifying and obtaining illustrations from Herbert A. Kellar, curator of Chicago's McCormick Historical Association. Kellar's job was to collect material related to the McCormick family and to agricultural equipment—particularly reapers—and to the family's ancestral Virginia countryside. In that capacity he amassed a vast archive that drew Phillips to Chicago, and the two began a personal and professional relationship that lasted for decades. Kellar often served as Phillips's field agent, identifying and obtaining many of the manuscript sources so highly prized by the historian.[14] In addition to sharing a zeal for collecting rare Americana, Phillips and Kellar regularly exchanged old books, broadsides, manuscripts, and photographs or sold them to one another. Besides the aid of Barbee and Kellar, Phillips also

received help in illustrating *Life and Labor* from Benjamin G. Fernald, "an engineer and citizen-at-large"; Marie Bankhead Owen, wife of Alabama archivist Thomas McAdory Owen; and Elizabeth Willett Elmore, wife of Demopolis, Alabama, lawyer Benjamin F. Elmore.[15]

Phillips's photographic collection includes many more visual items than appeared in *Life and Labor*. His archive at Yale contains approximately six hundred images of the South, many of which probably were intended for use in completing the two remaining volumes of his projected "A History of the South," works unfinished when the historian died in January 1934.[16] Other images were employed in his classroom teaching and public presentations.

Landscape and architectural views dominate Phillips's collection, followed by documentation of labor practices and pictures of workers, black and white. The archive contains portraits as well as a series of images Phillips took in Africa in 1929–30 as an Albert Kahn Foundation fellow. There are lantern slides, prints, mounted prints, stereoscopic cards, and negatives—some nitrate and some safety. Phillips stored a portion of his prints and most of his negatives in envelopes from various photographic houses located in Atlanta, New Orleans, and Ann Arbor, roughly corresponding to the places where he taught, lectured, researched, or traveled. Since becoming part of the Phillips Papers at Yale, those envelopes have been discarded and the images organized and sorted according to subject category. To date 123 of the photographs have been digitized. Eighty-seven of them appear in this book.

One challenge posed by working with Phillips's archive is the difficulty in definitively attributing images to particular photographers. Captions in *Life and Labor*, jottings on the backs of prints or on negative envelopes, notations or signatures on the prints themselves, and familiarity with certain photographers' bodies of work provided clues and helped to determine sources for most of the pictures published here. Occasionally Phillips had prints or negatives made into lantern slides, thus creating some views that exist in three formats—negative, print, and lantern slide. Rarely did Phillips include captions or provenance information with lantern slides because he provided spoken commentary when using them to accompany his lectures and talks.

The sixty boxed glass slides were produced not by the creators of the various images, but rather by G. R. Swain in Ann Arbor, Michigan, or W. H. Dudley of Madison, Wisconsin, from print or negative copies provided by Phillips. The historian most likely used them to illustrate his class presentations or on the lecture circuit.[17] The larger collection contains stereoscopic cards depicting New Orleans and vicinity published by S. T. Blessing, among the easiest of the holding to identify. Some images attributed to specific photographers are printed and mounted on cardstock embossed with "H. C. Hall, Dyer Building, Augusta, Ga." While Harry C. Hall was a photographer and a studio and gallery operator in his own right, he did not take these pictures. However, Hall did offer developing and printing services to the growing number of amateurs wielding Kodaks in the community. Phillips or his representatives most likely had Hall develop and print their film or make copy negatives

and prints of already existing views. Phillips may also have purchased images taken by other practitioners from Hall's gallery when they illustrated a particular aspect of southern life the historian found especially important for his lectures or publications.[18]

Phillips's own photographs, most often of buildings or landscapes, generally were taken in series, such as several perspectives of the same house or a compilation of views taken during trips through rural Louisiana, Georgia, or South Carolina. Phillips's captioning of one image produced under these circumstances frequently enables identification of others of the same subject in that series. Working with the images from the outset, examining them first in the cardboard box as they were found in museum storage, proved invaluable in situating them within the larger collection. Proximity—which prints appeared in the same envelopes or folders, which negatives were in the same boxes, or which views were grouped together—provided essential clues for ascertaining their provenance. Some prints found in the collection appear to derive from well-known commercial photographers who were contemporaneous with Phillips, and further investigation confirmed this hypothesis.

For the most part, Phillips preferred to photograph buildings in the countryside, relying on commercially produced cards or friends' contributions for pictures of urban architecture. He appreciated that the range of historically important southern structures included more than the proverbial white-columned plantation mansions. Nevertheless a survey of his archive's architectural and landscape views suggests that Phillips was quite enamored of plantation architecture, and many views commemorate past antebellum splendor and the architectural expression of Old South ideals.

Phillips understood the southern built environment in an organic way, seeing housing as well as commercial structures as reflective of the culture they sheltered. In his lecture notes Phillips traced cotton-belt building practices back to Virginia, a region whose housing had in turn been modeled on that of seventeenth-century England. Southern colonial climate being what it was, builders in Virginia quickly adapted Greek and Roman porticoes to the vernacular classical architecture of the region in order to provide the verandahs and porches essential to surviving summer heat and humidity. A migrant to the cotton belt took his memories of this architecture with him but was forced to "first build temporary cabins of rough logs to shelter his family and his negroes." Phillips went on to explain how such a coarse dwelling, as a family's fortunes improved, would be upgraded and expanded as building materials and technology allowed.[19] Much of this information appears in *Life and Labor* along with images documenting elaborate plantation homes and various styles of cabins. Phillips meticulously photographed multiple views of "double and triple cabins" to gain a satisfactory visual representation of what he described in his text.[20] Besides various types of housing, Phillips recorded other aspects of the rural landscape, including an outdoor cotton press, tobacco barns, country churches, a small schoolhouse, abandoned slave quarters, ruins, rice fields, a rice mill, and evidence of what Phillips deemed poor agricultural practices.[21]

Representations of the southern rural economy appear in the archive in a wide variety of images depicting both work and general daily activities. A picture book of the entire process of cotton cultivation could be constructed from Phillips's collection, reflecting the important role Phillips assigned to cotton in defining and explaining the region. From multiple sources the historian assembled photographs of workers plowing fields, planting seed, "chopping" the crop, harvesting, weighing the pick, baling, and transporting the crop to market, then finally pictures of cotton-bale-covered docks, effectively tracing the life cycle of this important southern commodity. Phillips recorded cypress logging in Louisiana on film, along with two outstanding images of what appears to be longleaf pine pre- and postharvest. His archive also includes a few photographs of sugar-cane plantations, sugar houses, and their workers. Glimpses of daily life exist as well with laundry "al fresco," women taking breakfast pails to their husbands in the fields, mules returning to the barn at midday, roustabouts loading freight, and small wagons each carrying one or two bales of cotton clogging city centers. Mothers tending children and men and boys transporting various hard goods appear as recurring themes among the prints.

The most salient images in Phillips's archive are portraits. Whether he intentionally set out to create a gallery of southern citizenry remains unknown, but an unusual assortment of humanity gazes back at the viewer from protective folders. There are no famous generals or politicians here and few proudly middle class. Instead, as with his careful documentation of cabins and nonmonumental architecture, he gathered pictures of black and white southerners far from the top rung of the economic ladder. Long before Farm Security Administration photographers captured their images on film, poor white farmers and their families posed in front of spare mountain cabins and on vine-entwined porches for Phillips's agents. Phillips also took advantage of work by two masterful Georgia commercial photographers—William E. Wilson of Savannah and Robert E. Williams of Augusta—to augment his archive.

William E. Wilson opened his studio in Savannah, Georgia, in 1883 and remained in the city until relocating to Mobile in 1901. He described himself in city directories as "photographer" or "landscape photographer," and, like most others in the same trade, he cobbled together a living with studio work and small commercial jobs.[22] Wilson also produced "real photo" postcards, a hugely popular item in the late nineteenth and early twentieth centuries. These cards were genuine photographs, taken, printed in quantity (usually several hundred), and sold to the public. They filled a niche market for regionally significant sites, customs, or traditions that went unnoticed by national postcard printers. "Real photo" cards can usually be identified by captions etched on the negative itself. When printed, the caption appeared as a line of white print along the bottom. Usually the caption includes a number, a descriptive phrase or sentence, and the photographer's name.[23] Wilson often took as his subjects average citizens engaged in their daily activities. Like many other practitioners at the time, he produced for sale to whites images that reinforced negative black stereotypes of the period. His images in the Phillips collection, however,

generally document views of daily life—an outdoor cotton press, a black woman and children gathering firewood, cotton picking, wagons hauling cotton, and cotton shipping from Savannah.[24]

Robert E. Williams's images are of greater significance. Williams was a second-generation "colored" photographer who worked in Augusta from 1882 until at least 1908. His father, Robert Williams Sr., was a mulatto "Daguerre artist" who, according to 1870 census records, owned property worth one thousand dollars, most likely his equipment. By 1880 his son, Robert E. Williams Jr., was working with him. In 1882 Robert Williams Jr. labored as a photograph printer for J. Usher, a local photographer. In 1895 Robert Williams and Son operated their own photography studio on Broad Street, the only such establishment serving the black population of Augusta, Georgia, and the Richmond County area.[25] When not producing studio work for clients, Robert E. Williams Jr. traversed the town and countryside, taking pictures of Georgia black people as they went about their lives. He staged some of his pictures, posing subjects simply against a fence or on a porch, slowly but surely creating his own visual archive of black Georgia and South Carolina.[26] Williams images that Phillips collected include views of a local chain gang at work and baptisms in a nearby river. Such photographic representations of African Americans before 1920 are scarce, and Williams's work is compelling. Phillips's decision to include them in his collection further demonstrates the historian's intent to document a broad spectrum of southern life.

Definitively identifying Williams's work in the Phillips archive is difficult. Four images can be confirmed as Williams's creations based on holdings at other archives. Others appear to be photographs from series taken by Williams, or they closely fit his general genre or style.[27] Familiarity with the Williams studio answered a nagging question about how Phillips obtained so many candid views of the black community. Somehow Phillips came to know of Williams and his work, enabling the white scholar to assemble an unusual and extensive collection of photographs of African Americans in the early twentieth-century—studio portraits, posed outdoor portraits, and images of daily life that include working, shopping, or simply enjoying a Saturday afternoon. Phillips was not part of this world, and imagining a young white man with a camera in early Jim Crow—era Georgia moving unnoticed among these people and taking casual snapshots strains credulity. The ease and forthrightness of the subjects in these images—and their comfort with the person taking the pictures—is obvious. In addition Phillips's collection contains what are clearly studio portraits—a young black man in evening dress, a dignified elderly gentleman, a romantic boy in a tilted cap, and a prizefighter. Internal evidence within the collection points to Williams as the photographer.

How Phillips obtained these Williams images is uncertain. Williams's studio was near H. C. Hall's location in the Dyer building in Augusta, and Hall may have offered Williams's images through his gallery. Given Phillips's standard mode of operation, Hall may have known of the historian's interest in collecting particular kinds of photographs and served

as a go-between. Many of the images in the Phillips archive, and at least seventeen of the photographs included in this book are copies of documented Williams prints, fit within existing series of his work held elsewhere, or conform closely to his style and typical subject matter.

Provenance of Phillips's African images is clear. When awarded an Albert Kahn Foundation Fellowship in 1929, he decided to use his year to study plantations across the globe, with special attention to "Negro traits" among primitive populations that he wanted to see in Africa. Traveling westward across the United States and then the Pacific Ocean, he began in Japan and then traveled to China, Hong Kong, the Philippines, and Malaysia. Phillips visited his first plantations in Sri Lanka—tea and rubber—and noted cocoa, rice, and coconut estates on the island as well. From there he went to Suez and Cairo, intending to travel up the Nile. Along the way Phillips observed Egyptian cotton plantations and sugar fields as he moved further and further into central Africa. Two British officials in Sudan, Major J. R. N. Warburton and Captain H. F. Kidd, invited Phillips to travel with them via lorry to Amadi and then Maridi and Yambio on the Sudanese frontier. More travel northwest put Phillips in Source Yubu for Christmas 1929. Throughout his journey, the historian observed and recorded in journal and photographs his impressions of topography, agricultural and irrigation practices, native populations, climate, prevalent diseases, and indigenous plants and animals.[28]

As America's foremost expert on African American slavery, Phillips, not surprisingly, considered Africa an extraordinary laboratory, and he approached Africans with the scientific *mentalité* and method of the ethnologist. Phillips found most interesting two native populations—what he later termed the "Nilotic group of tribal stocks" and the "Azande."[29] Ensconced in central Africa, Phillips took many photographs. While annotations to particular photographs may be found among Phillips's papers, none of those images is present among the collection's lantern slides, prints, or negatives. Other of Phillips's African photographs do exist, however, and descriptions or explanations of their content may be gleaned from his postfellowship formal report to the Kahn Foundation as well as from other writings in his archive.[30]

Taken as a whole, Phillips's photographic collection helps to document the historian's gradual shift from defining southern history in economic terms to doing so largely in racial terms. Though "race" always played a role in Phillips's analyses, most of his early work focused minutely on the operations of what he termed the "plantation regime" and slavery's long-term economic unprofitability. As a young historian and southern Progressive, Phillips looked to the past for solutions to the post–Civil War South's economic problems, but by the late 1920s he had broadened and redirected his range of questions about southern history to focus more squarely on the meaning and power of race. His well-known 1928 essay "The Central Theme of Southern History" identified in white southerners "a common resolve indomitably maintained" that their region "shall be and remain a white man's country."[31]

Somewhat counter to the dominance of white southerners in his writings, Phillips's photographic archive contains many more images of black southerners than white southerners. Several explanations are possible. The simplest is that the Phillips family, prior to donating the materials, removed pictures of white people; yet there is no reason to believe this was done. There are some images of white people in the holdings, and there are other random inclusions—Christmas cards, vacation postcards, a journal offprint—that make intentional editing of the contents appear unlikely. More probable is that Phillips considered himself already expert on the finer points of white southerners or was uncomfortable treating them in such a clinical, anthropological fashion. Several images of poor white farmers and their families are present along with specific pictures of overseers, but the white southern ruling class—except for their housing—is noticeably absent. Instead Phillips worked diligently to build an archive documenting black southerners and the plantation economy.

The historian ultimately came to appreciate the depth of the black experience in America. Writing in 1931 in the *Yale Review,* he explained that African Americans' full story had yet to be told. Phillips predicted that it eventually would include "African folkways and American vestiges thereof, gang labor and slave discipline, abolition chaos, and latter-day repression, concubinage, quadroons and 'passing for white,' rural isolation and urban congestion, dialect and manners, caste and caste within caste, songs and prayers, sermons and schisms—the nonchalance and bewilderment, the very human hopes and fears, the protests and acquaintances of a somewhat peculiar people through cataclysmic changes in a very complex land."[32] Phillips's photographic collection echoes his prophecy.

The images of African Americans in Phillips's archive run the gamut from stereotypically racist cartoons, patronizingly captioned "humorous" tableaux, plates reproduced from anthropological texts, and daily-life genre scenes to dignified studio portraits.[33] On returning from his Kahn Fellowship year, Phillips added images of Africans to the collection even though he had come to believe that black Americans "had long since broken from their tribal stem and habituated to life in white man's America."[34]

Preoccupation with race is a leitmotif in Phillips's later work as well as his photographic archive. Though critics often note correctly that Phillips distrusted slave narratives as "biased" sources, he gradually accepted the importance of African American documentation in order to answer what his generation termed the "race problem."[35] Phillips's cache of images of black Americans reflects the historian's halting but nonetheless determined effort to understand African Americans and how their history and culture fit into his larger understanding of southern life. Having spent much of his professional life examining southern history through the prism of the master class, Phillips's collecting and displaying images of black southerners signifies at least a tentative effort to come to terms with the "other."

As he used them, Phillips's photographs affirmed and rarely challenged his suppositions about black southern life. His Jim Crow–era racial biases, his fascination with

southern agriculture and work practices, his love for the South and for southerners black and white, and his affection for antebellum architecture appear clearly in the pictures and in his handwritten notes and marginalia. Comments on the backs of prints or on mountings frequently identify subjects and locations or add editorial remarks, linking the images to many of Phillips's manuscript sources that he and friends and colleagues gained during research trips in Dixie. In short, Phillips's photographs reinforced his arguments about the South and its people but also hint at a broadening realization that he needed to understand more deeply the role of black southerners. Through his archive Phillips assembled a broad spectrum of imagery from the era of Jim Crow—a diverse cross section of portrayals of white and black southerners, their surroundings, and their activities. With each new image Phillips worked to comprehend what he termed "a very complex land."

NOTES

1. Ulrich B. Phillips to David Rankin Barbee, June 10, 1928, Wendell Holmes Stephenson Papers, Perkins Library, Duke University (hereafter cited as Stephenson Papers).

2. Barbee to Phillips, June 3, 1928, Stephenson Papers.

3. See for example "A Snug House of Logs," in Ulrich B. Phillips, *Life and Labor in the Old South* (1929; reprint, Columbia: University of South Carolina Press, 2007), p. xii. For photographs provided to Barbee by others, see "Mansions and Cabins on the Savannah," no. 1, ibid., viii.

4. John David Smith, "'Keep 'em in a fire-proof vault'—Pioneer Southern Historians Discover Plantation Records," *South Atlantic Quarterly* 78 (Summer 1979): 376–91.

5. Phillips's graduate training at Columbia University placed him in an environment steeped in the "scientific" method then considered the most modern and progressive for social-science disciplines. His faith in empirical methodology led him to value not only texts and written records but also visual documentation, including photographs.

6. Merton L. Dillon, *Ulrich Bonnell Phillips: Historian of the Old South* (Baton Rouge: Louisiana State University Press, 1985), 64–71.

7. Phillips to Thomas M. Owen, December 7, 1903, Thomas M. Owen Papers, Alabama Department of Archives and History.

8. Ulrich B. Phillips personnel file, Tulane University Archives, n.d.

9. Dillon, *Ulrich Bonnell Phillips*, 31; John Herbert Roper, *U. B. Phillips: A Southern Mind* (Macon: Mercer University Press, 1984), 87.

10. "Ante-bellum South Is Vividly Described," *Galveston Daily News*, January 31, 1927, 2, clipping in Ulrich Bonnell Phillips Papers (MS397), Manuscripts and Archives, Yale University Library (hereafter cited as Phillips Papers, Yale).

11. Ulrich Bonnell Phillips, "Making Cotton Pay," *World's Work* 8 (May 1904): 4782, 4784, 4786, and 4792.

12. Avery O. Craven, review of Ulrich B. Phillips, *Life and Labor in the Old South, Political Science Quarterly* 14 (March 1930): 136.

13. Phillips, *Life and Labor in the Old South*, xii, xiii.

14. Dillon, *Ulrich Bonnell Phillips*, 120–21.

15. Phillips, *Life and Labor in the Old South*, vii–xiii. Following her husband's death in 1920, Marie Owen succeeded him as director of the Alabama Department of Archives and History.

16. Ibid., lvii.

17. Ulrich B. Phillips lantern slides, Phillips Papers, Yale.

18. For H. C. Hall's studio and gallery as well as other photographers operating in Augusta, see *Augusta City Directory 1889* (Atlanta: R. L. Polk, 1889), 196, 500; *Augusta City Directory 1891* (Atlanta: R. L. Polk, 1891), 196, 495; Walter Howard, comp., *Howard's Directory of Augusta, Summerville and Turpin Hill, Georgia and Hamburg, S.C. 1892–93*, vol. 1 (Augusta, Ga.: Chronicle Job Printing, 1892), 246, 576; *Chataigne's Augusta Directory 1895–96* (Richmond, Va.: Chataigne Directory Company, 1896), 134, 280; *City Directory of Augusta, Georgia, 1896–97* (Atlanta: Maloney Directory Company, 1897), 205, 371, 709; *Georgia Directory Co.'s Directory of Augusta, Ga., 1898* (Richmond, Va.: J. L. Hill Printing, 1898), 76, 222, 419; *Augusta City Directory 1899*, vol. 15 (Atlanta: Maloney Publishing, 1899), 404, 869; *Augusta City Directory 1901*, vol. 16 (Atlanta: Maloney Publishing, 1901), 293, 756; *Walsh's Directory of the City of Augusta, Ga., for 1902* (Charleston, S.C.: W. H. Walsh Directory Co., 1902), 267, 452, 827; *Walsh's Directory of the City of Augusta, Ga., for 1903* (Charleston, S.C.: W. H. Walsh Directory Co., 1903), 435, 828; *Walsh's Directory of the City of Augusta, Ga., for 1904* (Charleston, S.C.: W. H. Walsh Directory Co., 1904), 426, 807; *Augusta Directory 1905*, vol. 1 (Augusta: R. L. Polk, 1905), 260, 664; *Augusta Directory 1907*, vol. 2 (Augusta: R. L. Polk, 1907), 381, 859; *Augusta Directory 1908*, vol. 3 (Augusta: R. L. Polk, 1908), 341, 763; *Augusta Directory 1909*, vol. 4 (Augusta: R. L. Polk, 1909), 364, 777.

19. "Plantation Architecture," Ulrich B. Phillips lecture notes, Phillips Papers, Yale.

20. See Phillips, *Life and Labor in the Old South*, 328–30, and the illustration opposite page 340.

21. "Miscellanea," n.d., Phillips Papers, Yale.

22. F. N. Boney, "Candid Savannah: William E. Wilson's Photography on the Eve of the Twentieth Century," *Georgia Historical Quarterly* 73 (Spring 1989): 110. Both the Georgia Historical Society and the Hargrett Rare Book and Manuscript Library, University of Georgia, hold collections of Wilson's photographs.

23. Rosamond B. Vaule, *As We Were: American Photographic Postcards, 1905–1930* (Boston: Godine, 2004), 19, 68. Many notorious lynching postcards were "real-photo" cards.

24. "Miscellanea," Phillips Papers, Yale.

25. Bureau of the Census, *Ninth Census of the United States*, 1870, Washington, D.C.: National Archives and Records Administration, Augusta, Ward 3, Richmond, Georgia, roll M593 172, p. 100. Bureau of the Census, *Tenth Census of the United States*, 1880, Washington, D.C.: National Archives and Records Administration, District 123, Richmond, Georgia, roll T9 164, Family History Film 1254164, p. 536.2000, Enumeration District 104, image 0075; both censuses at http://search. ancestrylibrary.com (accessed August 18, 2009).

For occupational information on Robert E. Williams and Robert E. Williams Jr., see *Sholes' Augusta City Directory, 1882* (Augusta: Sholes, 1882), 91, 422; *Sholes' Directory of the City of Augusta, 1883* (Augusta, Ga.: A. E. Sholes, 1883), 92, 486; *Sholes' Directory of the City of Augusta, 1886* (Augusta: A. E. Sholes, 1886), 391; *Augusta City Directory 1888* (Atlanta: R. L. Polk, 1888), 455; *Augusta City Directory 1889*, 450, 500; *Augusta City Directory 1891*, 437, 495; Howard, comp., *Howard's Directory of Augusta, Summerville and Turpin Hill, Georgia and Hamburg, S. C. 1892–93*, 533; *Chataigne's Augusta Directory 1895–96*, 255, 281; *City Directory of Augusta, Georgia, 1896–97*, 665, 709; *Augusta City Directory 1899*, 826, 869; *Augusta City Directory 1901*, 722–23, 756; *Walsh's Directory of the City of Augusta, Ga., for 1902*, 779–80, 828; *Walsh's Directory of the City of Augusta, Ga., for 1903*, 742–43, 828; *Walsh's Directory of the City of Augusta, Ga., for 1904*, 759, 807; *Augusta Directory 1905*, 635, 664; *Augusta Directory 1907*, 808, 859; *Augusta Directory 1908*, 715–16, 763; *Augusta Directory 1909*, 731; *Augusta Directory 1910*, vol. 5 (Augusta: R. L. Polk, 1910), 716; *Augusta Directory 1912*, vol. 6 (Augusta: R. L. Polk, 1912), 734; *Augusta Directory 1913*, vol. 7 (Augusta, Ga.: R. L. Polk, 1913), 730; *Augusta Directory 1914*, vol. 8 (Augusta: R. L. Polk, 1914), 668, 711; *Augusta Directory 1915*, vol. 9 (Augusta: R. L. Polk,

1915), 743; *Augusta Directory 1917*, vol. 10 (Augusta: R. L. Polk, 1917), 773–74, 828; *Augusta Directory 1919*, vol. 11 (Augusta: R. L. Polk, 1919), 807; *Augusta Directory 1921*, vol. 12 (Augusta: R. L. Polk, 1921); *Augusta Directory 1925*, vol. 14 (Augusta: R. L. Polk, 1925), 1016.

26. Robert E. Williams Photographic Collection, Digital Library of Georgia, Hargrett Rare Book and Manuscript Library, University of Georgia, http://dlg.galileo.usg.edu/hargrett/williams/ (hereafter cited as Williams Collection; accessed April 2, 2012).

27. Duplicates of Phillips images figs. 54 (Yale 7085), 50 (7090), 49 (7092), and 55 (44179) appear in the Williams Collection. For reasons discussed earlier, other images, particularly African American studio portraits, most likely are also Williams's works. See, in particular, figs. 63 (7088), 64 (7089), 52 (7094), 66 (7095), 55 (44179), 56 (44180), 57 (44181), 58 (44184), 59 (44185), 53 (44186), 60 (44187), 65 (44192), and 67 (44194).

28. John David Smith, "U. B. Phillips's World Tour and the Study of Comparative Plantation Societies," *Yale University Library Gazette* 68 (April 1994): 158–62.

29. In fact the Nilotic group were peoples who inhabited the Nile region and or who spoke the Nilotic language. The Azande (also referred to as Zande) were people who inhabited the Congo-Sudan region of central Africa. They spoke the Adamawa-Eastern language.

30. "Negroes of the Sudan," "A Few Notes," "Photos," Phillips Collection, Yale. The published version of his report is Ulrich B. Phillips, "Nilotics and Azande," in Albert Kahn Foundation for the Foreign Travel of American Teachers, *Reports* (New York: Trustees, 1930).

31. Ulrich B. Phillips, "The Central Theme of Southern History," *American Historical Review* 34 (October 1928): 31.

32. Ulrich B. Phillips, "The Perennial Negro," *Yale Review* 21 (September 1931): 202.

33. It is perhaps surprising that the collection contains no lynching postcards. Phillips possessed a wide range of images portraying African Americans, including many that are condescending and racist.

34. Ulrich B. Phillips, "The Historic Civilization of the South," *Agricultural History* 12 (April 1938): 146. This article appeared posthumously.

35. In *American Negro Slavery: A Survey of the Supply, Employment and Control of Negro Labor as Determined by the Plantation Régime* (New York: D. Appleton, 1918), Phillips relied on Solomon Northup's *Twelve Years a Slave* (1853) yet warned readers that "books of this class are generally of dubious value" (see 445n64).

2

"Impressions are imperfect and his conclusions open to challenge"

Reading Ulrich Bonnell Phillips's Photographs

In his preface to the first edition of *Life and Labor in the Old South,* Ulrich Bonnell Phillips explained the tentative nature of writing history. "Every line which a qualified student writes is written with a consciousness that his impressions are imperfect and his conclusions open to challenge."[1] So too may be that student's readings of visual materials. Rather than a single unassailable rendering, a photograph may have meanings that are multi-layered and stem from multiple perspectives. That is their gift and their challenge.

Phillips liked using pictures to help make his points. As a photographer himself, he captured on film people and activities of the South, asked others to send him specific views, and—over decades—built a visual record of the region. But even as the photographs form an archive that Phillips and his associates created, they also simultaneously establish or support one or more "counterarchives" whose images are open to different readings than those assigned by Phillips.[2] Photographs are both information and object, and they are most valuable when viewed with this in mind. Phillips's collection is particularly ripe for examination because of the amount of information available about many of the pictures. Specific subjects are often known along with the reasons why Phillips sought the photographs, how they were produced, where they were employed, and who took them. Each picture carries specific information based on its content and provides insights into the political, social, and economic contexts surrounding its creation and subsequent use; it also exists as an object in its own right. The print, slide, or negative is a kind of material culture from Phillips's lifetime as well as an independent and persistent "thing." This essay examines selected images from the Phillips archive in more detail, considers the historian's sometimes idiosyncratic use of them, and briefly sketches possible alternative understandings.

As visual anthropologist Elizabeth Edwards notes, photographic content is the easy, obvious part of working with images.[3] Nevertheless the meanings that Phillips attached to the structures, people, and activities he documented are an important starting point. Exploring what Phillips understood as relevant content in the photographs exposes much about the historian's thought process and attitude toward his subject. Through his captioning, Phillips not only attempted to control the viewer's understanding of the illustrations but also revealed those aspects of the images that he did *not* find important. Even more thought provoking may be those pictures that he did not use in publications but assembled as a working collection in support of his ongoing research.

Phillips did not seek out fine-arts photography. Images in his collection with particularly artistic composition or effects are present only insofar as they convey evidence for his historical interpretations. His purposes were much more anthropological than artistic, and the evidentiary or documentary function of photographs was his first concern. When sorted by traditional photographic genre, the holding offers examples of landscape and architectural views, social documentary work, portraits, African vernacular representations, and pseudoscientific ethnographic images. These divisions are not exclusive, and many of the pictures may fit one or more of these conventional groupings.

As a photographer, Phillips was clearly most interested in and comfortable with landscape and architectural views. Urban and rural settings and buildings of all types are not only the most prevalent subjects in the collection but also the kind of picture Phillips most frequently took himself. They dominate his photographic archive and represent the largest single genre among the lantern slides as well as the plates in *Life and Labor in the Old South*. The majority of illustrations in *Life and Labor* are either photographs—ten attributed to Phillips—or reproduced engravings, maps, or drawings of various types of southern landscapes or housing. Even when human figures are present, Phillips focused in his captions on the architectural features of the structures. In the book and among the lantern slides, plantation plats and maps supplement the photographs of plantation homes.

Phillips was traditional in the style of building and countryside photographs he made and used. Most of his plantation images (see, for example, figs. 1–4) are frontal or three-quarter views of a main structure, generally with the photographer looking up at the building from a distance. The homes are centered in the upper portion of the frame with expanses of lawn in the foreground. The photographs exude wealth and stability, a solid foundation for the culture and economy of the region. The historian also admired long avenues of approach (figs. 5–7)—generally noteworthy for overspreading live oaks and hanging moss—creating the implication that an unseen, splendid plantation home was somewhere in the far distance. The entire archive contains many more landscape and building photographs than Phillips used in his lectures and publications, and some are clearly meant to record unusual or exceptional examples of traditional southern structures. One short series (figs. 8–10) documents the E. S. C. Robertson plantation in Salado, Texas.

While the main house is a large, two-story clapboard building, the slave quarters, complete with horse tied to hitching post out front, is a long, communal building made of brick or adobe, fenced and with a stile for access—an extremely unconventional plantation complex.

Over time Phillips assembled an extensive rural architectural archive. "Houses of the Most Common Southern Type" (fig. 11), "Cotton Gin House" (fig. 12), "Cotton baling press" (fig. 13), a solitary log cabin in the woods (fig. 14), plantation cabins (fig. 15), an abandoned plantation schoolhouse (fig. 16), and overgrown derelict chimneys (fig. 17) combine vestiges of the antebellum past with present-day realities, visually summarizing Phillips's vision of the New South countryside.[4] Occasionally he commented on the land itself. One long shot of fields with a house on a hill in the distance (fig. 18) includes his note, "horizontal plowing and terracing in the cotton belt," with "slipshod terracing" conveying his opinion of the farmer's effort. Phillips's buildings and landscapes, however, are empty and static; human activity is implied but not shown. Phillips's architectural images are exemplars—models supporting his textual discussions of the southern economy. Absent any modern content—newer structures, specific individuals, automobiles, or telephone and power lines—they are in effect timeless. Phillips may have been writing about the New South, but his images reinforce the persistence of an antebellum milieu.

Yet people are among the subjects of the archive elsewhere. Years before Roy Stryker's Farm Security Administration photographers, Phillips and his associates compiled pictures of mostly rural southerners at home and at work. In general these images fit within the social documentary genre, and no doubt Phillips intended they be used for that purpose.[5] Whether obtained during his travels or received from his cadre of field agents, the photographic record he gathered of southern rural folk, economic activities, and culture supported his interpretation of the region's past and his judgment about the best path for its future. For the most part, Phillips collected images of white southerners in the backcountry and largely built his collection of African American representations from urban sources.

In 1903 Phillips and "an elocution instructor" ventured into eastern Tennessee in search of "we'uns and you'uns" country. Phillips traced their expedition's progress to Knoxville and Maryville and then through the countryside to Tuckaleechee, a small settlement near Chillowee Mountain. In their travels the two stayed with a farmer of the "cove," and Phillips made careful notes of the family's economic situation. The man farmed fifteen acres of land (out of two hundred left to him by his father) and remained there despite the economic challenges. Corn, oats, and wheat, an apple orchard, and a vegetable garden as well as "three cows, fifteen sheep, seven hogs" served the family's needs. Bartering supplied additional requirements, and Phillips mused that "his cash income is perhaps less than ten dollars a year."[6]

Phillips made use of what he learned on that trip for anecdotes included in *Life and Labor in the Old South*, but captions for images in the book reveal Phillips's discomfort with publicly acknowledging the human subjects in his photographs. Illustration notes in the

front matter are elaborate, and he clearly tried to direct the reader's interpretation of the pictures. In the chapter titled "Homesteads," Phillips used four photographs of buildings (figs. 21–24) in which people figure prominently, but none of the individuals is identified. Human habitation is crucial to the concept of a homestead, and Phillips described various plantation families and even his own experience as a youth in Georgia in the chapter text while barely acknowledging the people in the pictures. David Rankin Barbee obtained three of the photographs (figs. 21–23) and the other likely came from the Williams studio in Augusta (fig. 24), adding to the historian's distance from the images.[7]

Two of the views used to illustrate the chapter fail to acknowledge any human presence whatsoever, despite the central position of a large white family in one (fig. 23) and five black children in the other (fig. 24). Longer, front-matter descriptions concentrate exclusively on the cabins' construction and location; captions with the photographs say only "In the North Carolina Mountains" and "In the Lowlands," with Phillips coyly grouping the two photographs as "Log Cabins with Blond Inmates and Brunette."[8] The other illustrations in "Homesteads" implicitly identify the people included, but only in terms of the family patriarch. "George Nessler's home" and "Interior of Nessler's cabin" are all the information supplied to the reader; the ten other people standing in front of the cabin (fig. 22) or the woman and five children seated inside (fig. 21) go unmentioned. Phillips's description of the Nessler cabin is generally laudatory. He noted that "the hewn logs are well fitted" and that "the walls are neatly boarded inside." In discussing the interior view, the historian focused on the fact that "the ceiling is papered with a dealer's samples, and the walls are completely hidden by various devices."[9] The family's generally healthy and happy appearance as well as the cleanliness and neatness of the interior are noteworthy and counter more common depictions of southern mountain poverty that emerged in the next decade.

Contrary to its chapter title, images accompanying "The Plain People" show buildings with people present in only one of the images (four in total; three of which are published here: figs. 25–27). While descriptive discussions about the demographic group under review fill the surrounding text, Phillips again did not acknowledge the specific human figures in his photographs. "The Plain People," contains images of people only incidentally, despite their explicit inclusion in the title. Figure 27 includes a black woman and two small children, and they are mentioned but only in terms of their value for demonstrating relative size: "the woman and her twins indicate the scale of the fireplaces."[10] Phillips took this picture himself, so identifying the woman and her children would have been an easy task, but the historian did not consider the information necessary for his purposes. The three other pictures in this chapter are of dwellings. At no time did Phillips truly engage with the human content of the photographs in either "Homesteads" or "The Plain People." He used the images to document housing styles, failing to note or investigate the particular lives of the people captured by the lens and ignoring completely any similarity of situation between the black and white inhabitants.

Other pictures of plain folk are in the archive but were never published as part of any of Phillips's work. One (fig. 29), an image of a man posed in front of a cart of firewood, has a caption on the verso: "A Georgia poor white 1902" and was perhaps taken by Phillips.[11] Another (fig. 30) shows an overgrown cabin with a child on the front porch and has notations on the verso suggesting that it might have been intended for use in *Life and Labor* and was probably collected by David Rankin Barbee.

A few other pictures of individuals occur in the collection, with some information supplied by Phillips. Two images (with notes on the verso) record overseers—"Overseer—Waterproof Plantation" (fig. 31) and "Mr. Allain (mounted) and Mr. Proctor Overseers Albamia Plantation" (fig. 32). In both views authority is clear. The Waterproof Plantation overseer, dressed in a suit, is mounted and positioned on the left side of the image with open fields to the right. Workers are implied; he surveys empty, barren fields. Allain and Proctor are on a road with Allain in shirtsleeves and on his horse and Proctor, in a suit, standing nearby. They occupy defined space away from the fields. Other horses graze in a nearby pasture, but what exactly the men are overseeing is unclear; there are no workers in the surrounding area. While Phillips's photographs convey the information that overseers are used in modern plantation operations and that they may fulfill their responsibilities on horseback, the historian fell short of documenting the work itself. White mounted supervision of black field-workers, as reminiscent as it is of slavery, may be more acceptable in the abstract. Phillips was engaged in promoting the modern South, not reasserting in such a visual way uncomfortable continuities. A counterpoint to the overseers photographs may be "Hands at noon, Dunleith, Miss." (fig. 33), which shows seven black workers lined up against a barn door. Dunleith was the Mississippi Delta plantation belonging to Phillips's friend Alfred Holt Stone, and the historian likely photographed the workers while visiting. Of varying ages and sizes, all are dressed in work clothes, some looking at the camera, some glancing elsewhere. Again no actual work is being done; white supervision or oversight may be understood by the viewer but goes unrepresented in the image.

Two series of photographs in the archive involve Louisiana industry. Engineer Benjamin G. Fernald took several photographs in 1909 that were used in *Life and Labor in the Old South* (figs. 35 and 36). They record work in the cane fields near Bayou Teche. Two others, unpublished in that work but included here, seem to be from the same series (figs. 37 and 38).[12] Captions for the Louisiana series in *Life and Labor* (figs. 35 and 36) are the shortest of any in the book. On a page headed "Gangs in the Cane Field," the first image, "A battery of plows," might be expected to show machines working the fields rather than the men and mules that appear in the view, perhaps wishful thinking on Phillips's part. The remaining photographs on the page do reference women and men ("women chopping grass" and "men's hoe gang,") but any expanded identification of the group, the plantation where they are working, or their process is absent.[13] Another image provided by Fernald (fig. 39) shows the front of a row of cabins on a sugar plantation and was used by Phillips in *Life and Labor*.[14]

A second group of Louisiana images, logging photographs (figs. 40–45), may also have been taken by Fernald, but captions on the backs of the prints in Phillips's handwriting hint that he could have been the photographer. In 1909, on completing his first year on the Tulane University faculty, Phillips traveled through the area visiting friends (perhaps Fernald) and seeking new manuscript sources for his research. Fresh off publication of *Plantation and Frontier, 1649–1863*, which explores the economic development and direction of the South, Phillips was still absorbed in studying the labor and industry of the region with an eye toward suggesting avenues of future development.[15] These logging photographs record activities, laborers, and equipment critical to an important Louisiana industry and do include African American work gangs along with teams of oxen, skidders, and locomotives. Notes in Phillips's handwriting on the backs of prints provide some explanations—and suggest that he was present when the pictures were taken if not the photographer. Individuals on the crews are unidentified, but their equipment and location are duly noted. A single picture of a woman on a porch (fig. 46) suggests some of the anthropological tendencies the historian could display. "Old Negro woman on place formerly Judge Baker's Bayou Teche—there 30 years about 65 years old born at Opelousas-spoke English," he wrote. Like a scientist doing fieldwork on a foreign culture, Phillips carefully recorded her age, residence, and origins. In the image the woman is seated in profile on a chair facing away from the photographer; she may have been completely unaware that her picture was being taken. Two additional woodland views (figs. 47 and 48) show what appear to be a longleaf-pine forest and then a raft of pine logs—perhaps "before" and "after" renderings. They have no written descriptions but effectively suggest the vast lumber resources in the South at the time, something that would have been relevant to Phillips's research.

Despite many instances in the collection, Phillips published few of the images of African Americans that he collected. Some of them exist as lantern slides, suggesting that he used them in his various classes or presentations, but there is no explicit statement of his intent in building a collection of African American vernacular images. Nevertheless the historian secured and preserved a broad and varied record of black photographic practice in the region. By saving these photographs, Phillips inadvertently created an extensive archive of black visual culture, compiling evidence of an active, engaged, prosperous black community in the early-twentieth-century South. This part of the collection is particularly useful when considered in light of recent work exploring the role of photography in the African American community.

With advances in photographic technology that made taking pictures both easier and less expensive, Americans of all races and classes visited local studios or took snapshots of their own to commemorate important events. Not only did the resulting images record the individual and the event but the photograph itself survived as an object—an independent, physical, authentic and accurate piece of evidence documenting achievement and status. Dressed in his or her finest clothing, seated on fashionable furniture, and situated among

evocative props, anyone could be presented in the best possible light—literally. For African Americans, photography during this period was especially important. Through photographs, black Americans sought to "transform the public image of African Americans and to challenge the stereotypical images that showed blacks as subordinate to the dominant culture."[16] When he created photographic albums for the American Negro Exhibit at the Paris Exposition in 1900, W. E. B. Du Bois wanted viewers to see "several volumes of photographs of typical Negro faces, which hardly square with conventional American ideas."[17] Du Bois's "typical Negro face" generally came from the "Talented Tenth" he championed and reflected his efforts to substitute a solid middle-class representation of black Americans for the prevailing denigrating stereotypes. Writing in 1979 for a book of the works of Tuskegee Institute photographer P. H. Polk, Pearl Cleage Lomax remarked: "These who believed that if they gave to the world the best that they had, the best would come back to them. These worked hard to mold themselves into the shapes prescribed by the wider world, and when they were satisfied with the results, when their appearances especially pleased them for one reason or another, then these called for an appointment, bathed and dressed the family, and had a portrait made."[18]

Studios owned and operated by African American photographers appeared commonly in southern urban areas, and itinerant black cameramen frequently traveled regular circuits, visiting small towns and producing views of families, special occasions, or places of interest. Sometimes white photographers would set aside specific hours or days for black clients if there were no local black practitioners.[19] Increasingly work from some of these early black commercial studios is being published or made available through digitized archives, and historians are exploring this special relationship between photography and the black community.[20]

With the Phillips collection, we have some of those carefully constructed studio works and an impressive array of outdoor portraits and genre pictures—images of everyday life. As mentioned above, many of them appear to be the work of Robert E. Williams Jr., an African American commercial photographer who worked with his father and later his own son over several decades in Augusta, Georgia. Phillips kept five studio portraits (figs. 49–53) as lantern slides, two of which (figs. 49 and 50) are duplicates of Williams photographs held by the Hargrett Rare Book and Manuscript Library at the University of Georgia.[21] Two images of a baptism scene also look like Williams images; one is a duplicate (fig. 54) while the other (fig. 55) appears to be from the same series. Several additional pictures (figs. 56–63) resemble other Williams images because of their subjects' poses, backgrounds, or ease before the camera. Other potential Williams works include two pictures of a chain gang (figs. 65 and 66) and an image of an institutional setting labeled "Negro Men's ward, Georgia Lunatic Asylum" (fig. 67).

A series of prints, identified by Phillips as "Saturday afternoon in a country town. Milledgeville, Ga., 1904," consists of candid street scenes, group, and individual portraits (figs. 68–75).[22] This Saturday afternoon sequence depicts the bustling black neighborhood

of the former Georgia capital—drug, grocery, dry-goods, and home-furnishing stores—as residents go about their weekly activities. Ladies in hats and shirtwaists stroll the sidewalks or sit primly on cartons. Men stand in groups or stride down the street. Some characters appear in more than one image. A few people had their individual portraits taken by the photographer, but they remained on the street for the occasion. Phillips did not specify that the photographs document the black district of the town, but there are no white citizens to be seen in any of the views, one of the reasons why attributing the photographs to Phillips is an unlikely scenario. It is more probable that Williams walked along with the market-day throngs, capturing candid shots and quick portraits as he went. The series is rare in its ordinariness, an unusual depiction of black daily life in a small southern town.[23] Phillips was quite taken with this series from Milledgeville. His parents had moved there in 1897, and the historian visited frequently while in college and in later life. Several images from this group exist within the archive in print, negative, and lantern-slide formats.

Also included among the African American images are posed outdoor portraits, pictures of individuals who have been positioned or stopped by the photographer so that their pictures may be taken. Similar images appear in the Williams archive at the University of Georgia. The photographer was particularly fond of posing people in front of fences, in roads, or with oxen, and he frequently staged scenes with children. Whether Williams or some one else took the pictures that Phillips collected, the photographs offer views of typical black citizens—old and young, a Sea Island militiaman, mother and children, and more. Image by image, Phillips assembled a compendium of black southerners in the decades around the turn of the twentieth century.

These images of southern African Americans, many likely taken by Robert Williams, constitute some of the most important in the collection. Whatever Phillips's reasons for accumulating works by the black photographer, the resulting archive preserves for posterity a valuable counterarchive of black representations in direct opposition to popular stereotypes of African Americans in the early-twentieth-century South and Phillips's own view of black southerners as childish and relatively inept.[24] The Williams images are subversive, creating a visual record of propriety, dignity, religiosity, and engagement. The black subjects in the photographs may not all fit Du Bois's middle-class ideal, but they effectively refute notions of venality, criminality, and silliness. To the extent that they do not represent the Talented Tenth, they offer an alternative vision of African Americans in opposition to both vicious white stereotypes and Du Bois's ideal of respectability.

Five studio portraits in the collection (figs. 49–53) offer an opportunity to delve into possible meanings that Phillips might have attached to these images as well as meanings ascribed by other viewers. The pictures are gender neutral or identifiable as black men—a baby in a bowl, an artistically posed boy, an adolescent or young man in evening dress, a bare-chested adult man, and a seated elderly gentleman with crutches and glasses. Knowing that the Phillips archive also contains at least one slide of anthropological drawings

and a slide of the first page of Herbert Ward's article "The Real African" (*Scribner's Magazine*, October 1910), it is not out of the question to suppose that Phillips wanted to assemble a set of images depicting African American men at significant stages of life.[25] That these images all exist as lantern slides also suggests that the historian used them in his public presentations about the South. In addition, Phillips identified none of the individuals in the portraits; for him they remained archetypes.

Along with their "scientific" or clinical value for Phillips, the images are also intriguing pictures of individuals at ease in front of the camera. The "baby in a bowl" picture (fig. 49) is a familiar genre among studio portraits of the time and confirmed to be the work of Williams. Posed in front of a potted plant, the infant looks to the left of the photographer in a thoughtful manner. The baby portrait conforms to the conventions of middle-class portraiture and demonstrates an effort by at least some black families to create a conventional domestic photographic record. Elsewhere in the archive is another print of this image that was used as an advertisement for soap, demonstrating yet another commodified racial stereotype. The happy baby is an attractive subject and considered appropriate for public display. It is unclear whether the promotional image was also created by Williams, but the charming infant clearly fit visual norms of the time.

The next image, that of a young boy (fig. 50) is more complex. An attractive child, the boy looks laughingly over the photographer's right shoulder; the boy has bright eyes, long eyelashes, and a brilliant smile. He is alert and animated, engaged with his surroundings. His clothes, however, are ragged and his hat either askew or tattered. While aesthetically striking as a beautiful portrait, the image could also be understood to represent the "happy Negro" stereotype—the African American as simple and joyful regardless of material condition. Read as artistic rendering or sociological specimen, the image carries different meanings depending on viewer and context.

The picture of a young man in evening dress (fig. 51) is compelling as well. He fills the frame and stares directly into the camera, top hat firmly centered on his head, his right hand gloved and holding another glove—the left hand grasping a cane. He is confident and self-assured in his finery even though it probably came from the photographer's standard wardrobe offerings.[26] Whether dressed in his own clothing or commemorated in borrowed costume, he is obviously not subservient or deferent; yet his age and demeanor defuse any implied threat. He is in some ways disarming. By dress not a field hand, laborer, student, or apprentice, he may be an exemplar of the New South or the clichéd "happy Negro." Regardless of interpretation, however, the photograph of this young man is a view of black adolescence that runs counter to white stereotypes of the early twentieth century.

The seated, adult black man (fig. 53), perhaps a prizefighter and the next model in Phillips's visual narrative, is bare chested except for a cord around his neck. As a picture of great physical strength, it is a complicated image for Phillips. The subject stares past the photographer. A direct gaze from so powerful an individual, especially a naked black man, would be too confrontational for white southerners at the time, bringing immediately to

mind the perceived danger posed by strong black men to wider white society. The subject also slouches, further reducing the implied threat. An absence of clothing, however, also allows the man to be seen as uncivilized, a savage possessed of raw, brute strength—an attribute Phillips often noted as useful given the black man's "natural" place as a laborer. Control of that strength, implied by the averted gaze and cord around the neck, was the key—for Phillips—to the successful integration of African Americans into the New South. That the portrait might commemorate a successful prizefighter with significant social status is an alternative description far away from the historian's intent.

The last image in the studio series is that of a seated, elderly man with some level of disability (fig. 53); he holds crutches in his left hand, against his knee. He is dressed in a clean white shirt, pants and a coat with a strap of some kind across his chest. Photographed from the waist up, he looks directly at the photographer, his glasses raised and balanced on his forehead, white hair, lined face, and beard attest to his age. Some might discern irritation in his look or simply forthrightness. The position of his spectacles suggests that the world might be too harsh to view clearly all the time, or that he is selective in what he examines closely. A less charitable reading might fault him for foolishness or stupidity, forgetting to use his glasses, or even having glasses that are useless. Phillips's subject might be a respected minister or professional, again reinforcing the many ways to view the individuals in these pictures.

What becomes apparent in examining the studio portraits is the multiplicity of readings that are possible. Whether viewed in an almost anthropological "stages of man" framework that fits with Phillips's potential agenda or as representations of unique and valued members of a larger community, the images can be understood as two (or more) archives that preserve and/or constitute different meanings depending on how, when, and by whom they are read. These pictures may be samples from the larger Williams archive; they may be family portraits; they may record an ambitious young person, successful athlete, or respected elder. While any photographic archive may offer multiple paths of interpretation, the images collected by Phillips, because they cover such contested terrain, are particularly rich and open to myriad assessments.

Phillips's African photographs (figs. 76–87), the latest and only non-American views of the collection, complement his existing holding and add another layer to it. Produced by the historian during his Kahn Fellowship year, the surviving photographs record only a small portion of his entire journey—his time spent among what he called the "Nilotic and Azande" tribal groups.[27] Phillips accepted wholeheartedly the notion that he—an observer from the civilized world—was in Africa to study primitive societies that might or might not have connections to his much more advanced and developed homeland. Phillips saw himself taking a "tour in a continent which is itself a museum of the primitive." He explained further that "to see its exhibits in the life and to have custodians on call for willing explanations keeps one alert, gives a grasp of human equations and a sense of at least partial penetration into the inwardness of strange practices."[28] The photographs Phillips took not

only documented the people and culture that he encountered but also hint at scientific race photography as well as anthropological and ethnographic photographic practices. Like Louis Agassiz, who sought daguerreotypes of slaves to support his theories of polygenesis (the now discredited theory that different races were in fact different species), Phillips captured "specimens" for his research on native Africans and their similarities to—or differences from—American blacks.[29] Welcomed by British hosts and availing himself of their expertise, Phillips busied himself generating a sequence of images that largely conform to ethnographic practice at the time.[30]

Information about the content of African images in the Phillips Collection may be gleaned from the draft of the historian's report to the Albert Kahn Foundation about his year abroad and from notes taken during his travels. Textual explanations of dress, customs, punishments, and rituals provide background for the pictures. As in his writings on the American South, Phillips devoted pages to describing native buildings and their mode of construction along with common tools and agricultural implements. Also as in his other texts, the historian detailed clothing customs, hairstyles, and weaponry without specifically identifying the individuals whose portraits he made. Toward the end of his report, he noted that "Negroes in American slavery made the best of their situation" and concluded that African blacks exist in a primitive, uncivilized world and are likely to remain there, needing the safety provided by their British protectors.[31]

Taken near the end of his life and never used in his published scholarship, Phillips's African photographs suggest the ongoing development of the historian's understanding of African Americans. His report to the Kahn Foundation is almost anthropological or sociological in tone—closely detailed observations and a descriptive narrative of his journey with only the barest of historical scaffolding. Despite his stated intent to compare American plantation operations with their global counterparts, his writings on this part of his journey mention little about agriculture and focus instead on the appearances and behaviors of the native groups he observed. The images fit well within the practice of anthropological photographic exchange at the time, but they are a discrete, isolated component of the larger Phillips archive. In some ways they bring the historian full circle: the "scientific" practitioner seeking to ground his broader theories of African and African American continuities—or disjunctions—with appropriate empirical data. And they further pushed him to reformulate his thinking about the role of African Americans in the southern past as well as their position in the region's future. While Phillips's African images are different from the rest of his archive in terms of subject, they nevertheless fit his program of "scientific" record keeping. While he may have attempted to document housing, costume, and daily life, the images come across as fairly typical tourist views—unusual natives and their dress, hats and headdresses, dancing, and huts. They are even somewhat voyeuristic, recording the appearance of men captured by their enemies and ritually punished (fig. 78). If anything, Phillips documented the differences of Africans from African Americans in the late 1920s, a problematic finding. Where he sought persistence and continuities between

the two groups, his own experience argued against such cultural survivals in the American South. Having carefully recorded his actions and observations and with visual evidence of contemporary African societies, Phillips returned to the United States convinced that race relations were crucial to understanding southern history and that it was necessary to reconsider the role of African Americans within the region's past, present, and future.

During the course of his career, U. B. Phillips amassed hundreds of provocative images. The above discussion begins the effort to trace some of the most basic and most obvious meanings that might be attached to the collected prints, slides, and negatives. Hundreds of images besides those published here await researchers. In building his photographic archive, the historian gathered visual documentation to support his broad understanding of the southern past and his evolving vision of the region's future. He collected real-photograph postcards, studio portraits, architectural renderings, vernacular photographs, and pictures documenting work and workers. By his attention more to a picture's content than its pedigree, he also preserved a valuable sampling of contemporary imagery. Certainly we learn about Phillips by considering his pictures, but, because we are engaged with photographs, we open doors to other discussions—the "ongoing entanglement of the photographic object in multiple histories and thus multiple trajectories."[32]

NOTES

1. Ulrich Bonnell Phillips, *Life and Labor in the Old South* (1929; reprint, Columbia: University of South Carolina Press, 2007), lvii.

2. The notion of a counterarchive derives from recent analysis of the historical and cultural status of museums and archives. By their position as text and object within an archive, photographs are particularly open to alternative readings. Just as they may contribute to the content and authority of a particular discourse, they may also, as independent objects, carry other, equally valid meanings and help to construct an alternative discourse. For discussions of archives and their multiple meanings, see "Observations from the Coal-Face" and "Exchanging Photographs, Making Archives," in Elizabeth Edwards, *Raw Histories: Photographs, Anthropology and Museums* (Oxford, U.K.: Berg, 2001). One way of understanding the photographic albums W. E. B. Du Bois created for the 1900 Paris Exposition, for example, is as a counterarchive to then-accepted visual and cultural stereotypes of black Americans. See Shawn Michelle Smith, *Photography on the Color Line: W. E. B. Du Bois, Race, and Visual Culture* (Durham: Duke University Press 2004), 7–12.

3. Edwards, *Raw Histories*, 2.

4. All quotations of image descriptions are from the illustrations list in Phillips, *Life and Labor in the Old South*, xiii, x, xi.

5. The best-known images from the rural South continue to be those taken during the Great Depression through the efforts of the Farm Security Administration (FSA) to document the hardships of the era and the effects of New Deal programs. The easy availability of these photographs through the Library of Congress website—http://www.loc.gov/pictures/collection/fsa/—as well as publication of state-based or photographer-based collections can sometimes obscure the fact that many local practitioners were documenting the region long before the 1930s. For FSA works, see for example Robert L. Reid, *Picturing Texas: The FSA-OWI Photographers in the Lone Star State, 1935–1943* (Austin: Texas State Historical Commission, 1994); Michael Carlebach and Eugene F. Provenzo Jr.,

Farm Security Administration Photographs of Florida (Gainesville: University Press of Florida, 1993); Stephen J. Leonard, *Trials and Triumphs: A Colorado Portrait of the Great Depression, with Farm Security Administration Photographs* (Niwot: University Press of Colorado, 1993); Dorothea Lange, *The Photography of Dorothea Lange* (Kansas City, Mo.: Hallmark/Abrams, 1995); Ben Shahn, *Ben Shahn, Photographer: An Album from the Thirties*, edited by Margaret R. Weiss (New York: Da Capo, 1973). For pre-FSA southern images, see for example Thomas L. Johnson and Phillip C. Dunn, eds., *A True Likeness: The Black South of Richard Samuel Roberts 1920–1936* (Columbia, S.C.: Bruccoli Clark, 1986); Harvey S. Teal, *Partners with the Sun: South Carolina Photographers, 1840–1940* (Columbia: University of South Carolina Press, 2001); Thomas L. Johnson and Nina J. Root, eds., *Camera Man's Journey: Julian Dimock's South* (Athens: University of Georgia Press, 2002); and Jerry W. Cotten, *Light and Air: The Photography of Bayard Wootten* (Chapel Hill: University of North Carolina Press, 1998).

6. Unpublished manuscript, n.d., Ulrich Bonnell Phillips Papers (MS397), Manuscripts and Archives, Yale University Library (hereafter cited as Phillips Papers, Yale).

7. Phillips, *Life and Labor in the Old South*, xii, and facing 330 and 334. In the front matter Phillips noted that the source for image 7054 (fig. 24) is "forgotten."

8. Ibid., facing 330.

9. Ibid., xii.

10. Ibid.

11. All photographs mentioned in this work may be found in the Phillips Papers, Yale.

12. Phillips, *Life and Labor in the Old South*, 339–49.

13. Ibid., ix–x.

14. Ibid., facing 165.

15. Ulrich B. Phillips, *Plantation and Frontier, 1649–1863, Illustrative of Industrial History in the Colonial and Antebellum South: Collected from MSS. and Other Rare Sources*, 2 vols. (Cleveland: A. H. Clark, 1909).

16. Deborah Willis, "Representing the New Negro," in *African American Vernacular Photography: Selections from the Daniel Cowin Collection* (New York & Göttingen: Steidl, 2005), 17.

17. W. E. B. Du Bois, quoted in Shawn Michelle Smith, *Photography on the Color Line: W. E. B. Du Bois, Race, and Visual Culture* (Durham: Duke University Press 2004), 6. Phillips and Du Bois disagreed about most aspects of southern history, but both historians recognized the potential impact of photographs to convey their points.

18. Pearl Cleage Lomax, essay in *P. H. Polk: Photographs* (Atlanta: Nexus Press, 1980), 106.

19. Willis, "Representing the New Negro," 19.

20. See for example Johnson and Dunn, eds., *A True Likeness;* Herman Mason Jr., *Hidden Treasures: African American Photographers in Atlanta, 1870–1970* (Atlanta: African American Family History Association, 1991); *P. H. Polk: Photographs;* Deborah Willis, ed., *J. P. Ball: Daguerrean and Studio Photographer* (New York: Garland, 1993); Willis, ed., *Picturing Us: African American Identity in Photography* (New York: New Press, 1994); Deborah Willis-Thomas, *Black Photographers, 1840–1940: An Illustrated Bio-Bibliography* (New York: Garland, 1985).

21. Robert E. Williams Photographic Collection, Digital Library of Georgia. Hargrett Rare Book and Manuscript Library, University of Georgia. http://dlg.galileo.usg.edu/hargrett/williams/ (accessed May 25, 2012; hereafter cited as Williams Collection).

22. Seven images from this series are published here; more exist within the larger archive, but they are repetitive or of lesser visual interest.

23. The only apparent research resulting from the Williams Collection at the Hargrett archive has been a master's degree candidate's use of the images to analyze African American working-class

clothing. See Sara Beth Brubaker, "African American Working Class Clothing as Photographed by William E. Wilson and Robert E. Williams," master's thesis, University of Georgia, 2002.

24. Forty-eight of the eighty-six images available through the digitized Williams Collection are individual or group portraits taken either in a studio or a natural setting. Some of them are posed— children playing marbles, eating watermelon, or engaged in some kind of staged interaction. Other pictures record groups in front of houses, men and women in the fields, women doing washing, mothers tending children, men driving oxcarts, or individuals who have stopped their daily activities to be photographed. In all these views, the subjects look directly at Williams. The remaining works are candid shots in which the subjects pay no notice to the photographer. See Williams Collection.

25. For examples of anthropological images in the collection, see images 7096 and 7097, Phillips Papers, Yale.

26. Willis, "Representing the New Negro," 19.

27. "Negroes of the Sudan," typescript, Phillips Papers, Yale.

28. Ibid., 1.

29. For Agassiz and his use of slave photographs, see Brian Wallis, "Black Bodies, White Science: Louis Agassiz's Slave Daguerrotypes," *American Art* 9 (Summer 1995): 39–61; Molly Rogers, *Delia's Tears: Race, Science and Photography in Nineteenth-Century America* (New Haven: Yale University Press, 2009).

30. For the use of photographs in documenting anthropological observations as well as the critical role of photographic exchanges between and among professional and nonprofessional sources in constituting modern anthropological practice, see Edwards, "Exchanging Photographs, Making Archives," 27–50. British anthropologists in particular received many images from British Foreign Office sources in the field.

31. "Negroes of the Sudan," 60; see also John David Smith, "U. B. Phillips's World Tour and the Study of Comparative Plantation Societies," *Yale University Library Gazette* 68 (April 1994): 165.

32. Edwards, "Observations from the Coal-Face," 22.

THE PHOTOGRAPHS

Information in quotation marks derives from notations on the images or their mountings or from Phillips's publications. All photographs are from the Ulrich Bonnell Phillips Papers (MS397), Manuscripts and Archives, Yale University Library. A complete listing of Phillips's notes, marginalia, and captions may be found in the appendix.

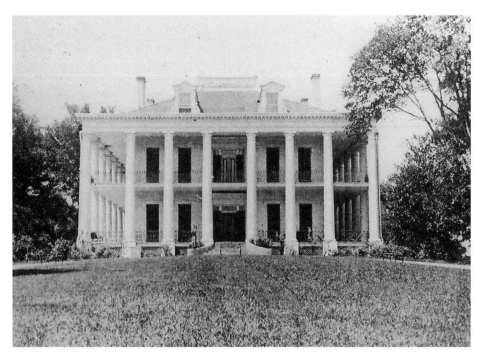

1. Antebellum plantation home

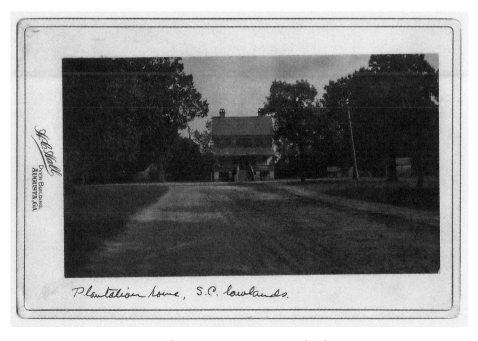

2. "Plantation Home, S.C. Lowlands"

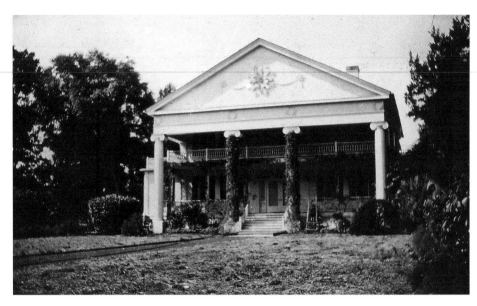

3. Plantation home

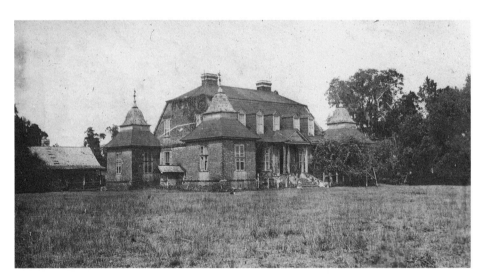

4. "Mulberry Castle, on Cooper River," Charleston, South Carolina

5. Approach to a plantation home

6. "Avenue Within the Gate"

7. "Gateway to The Oaks," South Carolina

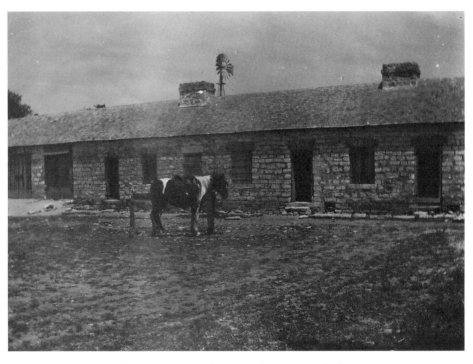

8. "Slave quarters," Robertson Plantation, Salado, Texas

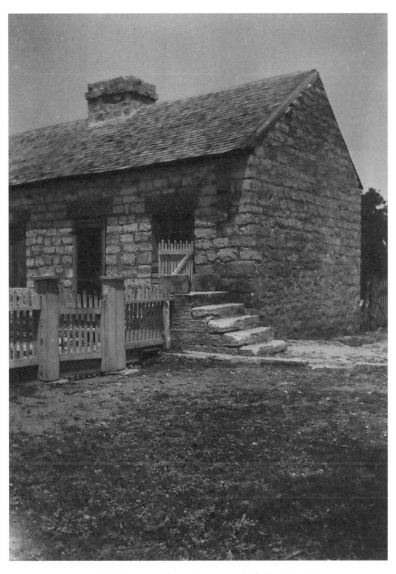

9. "Robertson Slave Quarters, Salado, Texas"

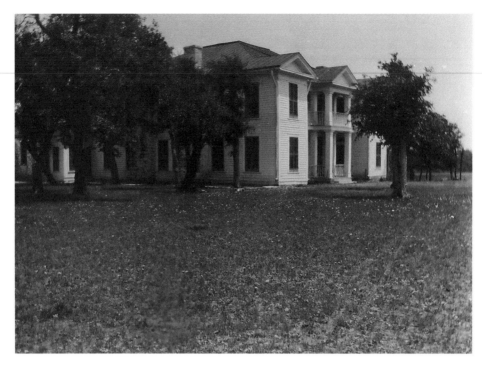

10. "E. S. C. Robertson Plantation Home—Salado, Texas"

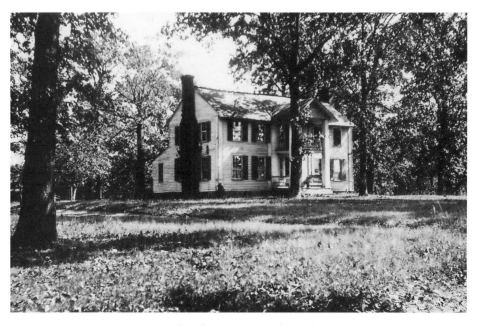

11. "In the Georgia Piedmont"

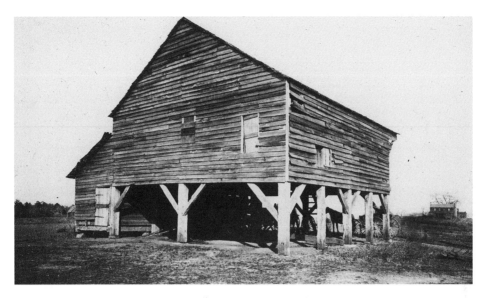

12. "Cotton Gin House"

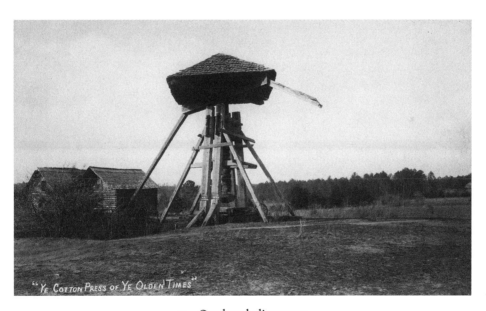

13. Outdoor baling press

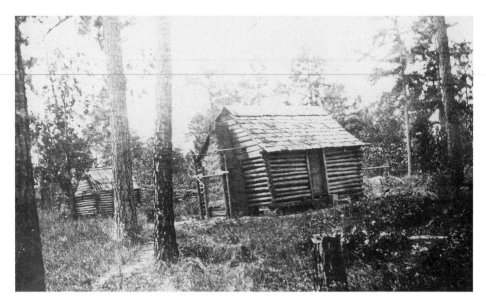

14. "Negro cabin … Woodlawn Plantation, Berkeley County, S.C."

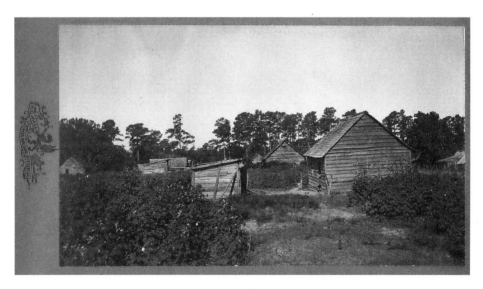

15. Cabins

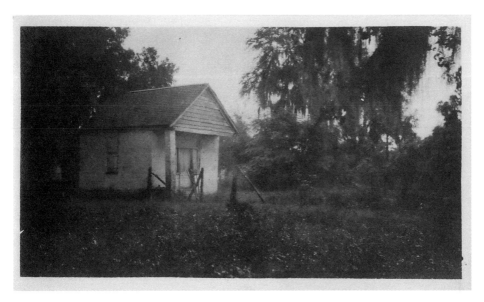

16. "Plantation Schoolhouse, Cooper River, S. C."

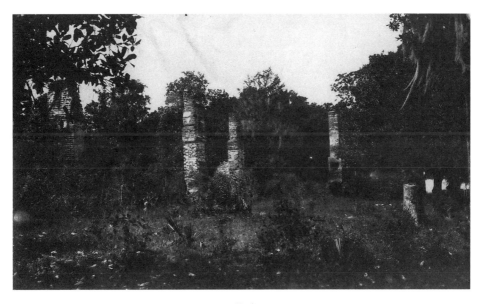

17. Ruins

18. Example of "horizontal plowing and terracing in the cotton belt"

19. Rice fields

20. "Carting Sheaves of Rice . . . Jehossee Island," South Carolina

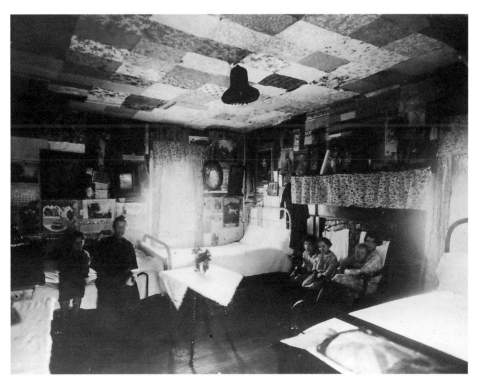

21. "Interior of Nessler's Cabin"

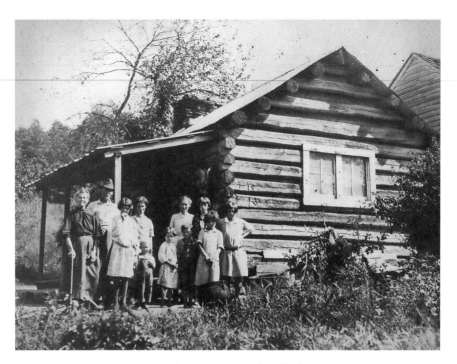

22. "George Nessler's Cabin"

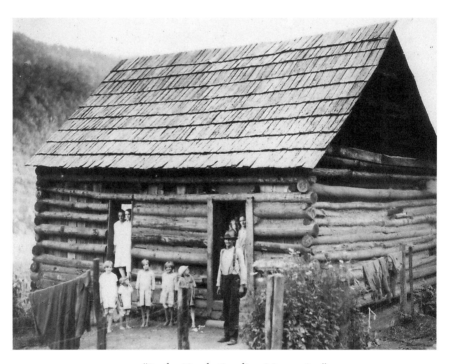

23. "In the North Carolina Mountains"

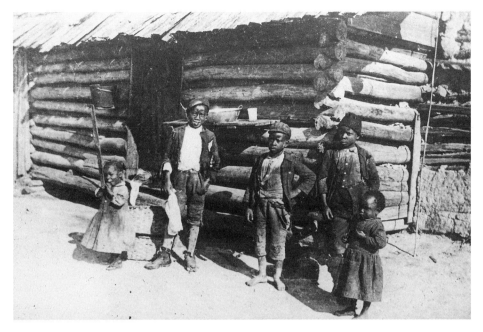

24. "In the Lowlands"

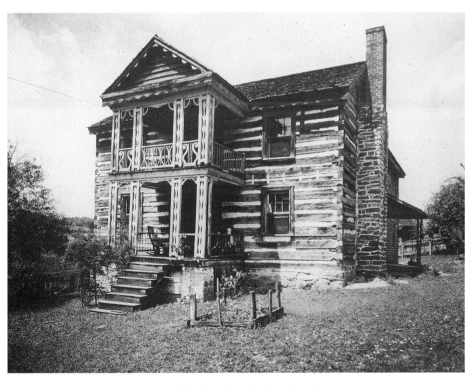

25. "The height of style in logs"

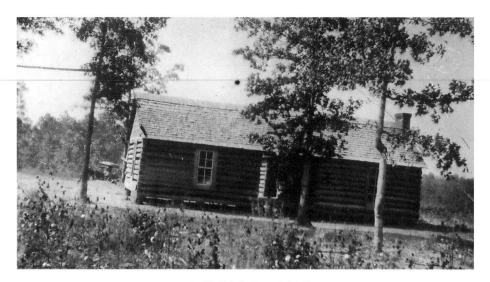

26. "A Triple Log Cabin"

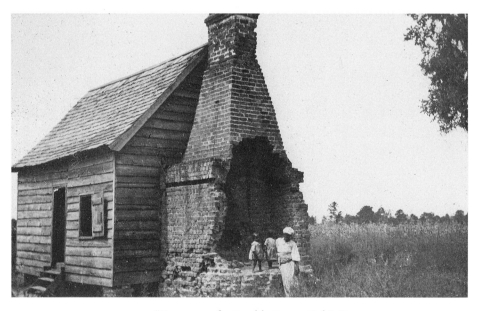

27. "Remnant of a Double Frame Cabin"

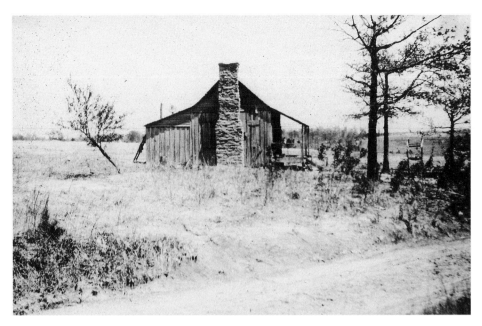

28. Triple log cabin, alternate view

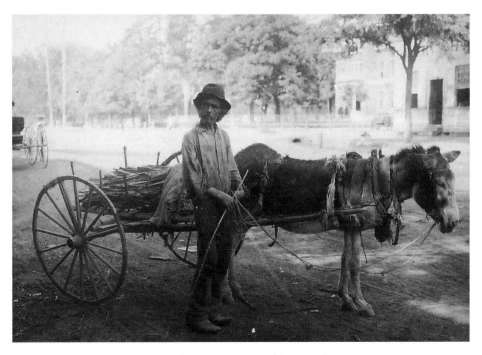

29. "A Georgia poor white 1902"

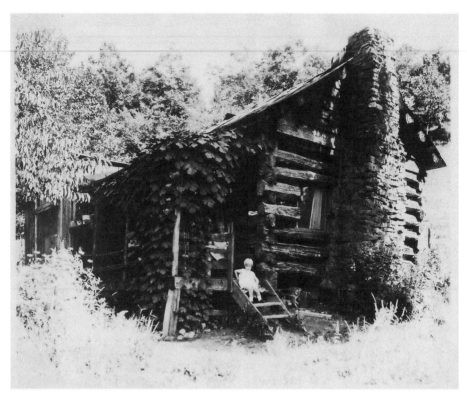

30. "W. T. Paris Cabin on the banks of the Tuckaseegee"

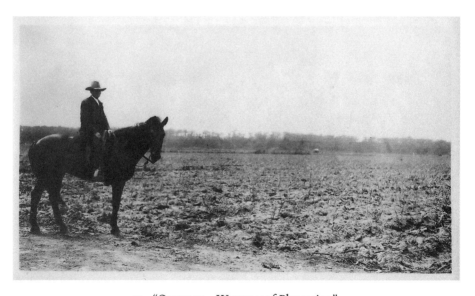

31. "Overseer—Waterproof Plantation"

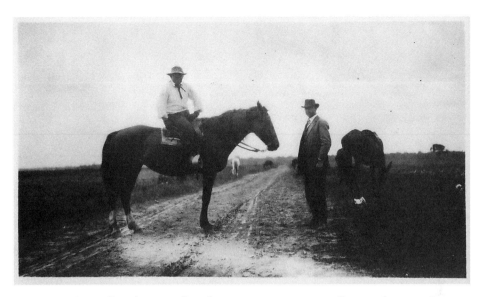

32. "Mr. Allain (mounted) and Mr. Proctor Overseers Albamia Plantation"

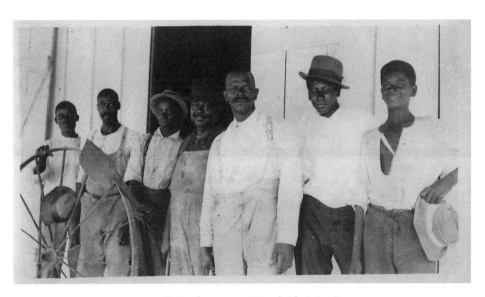

33. "Hands at noon, Dunleith, Miss."

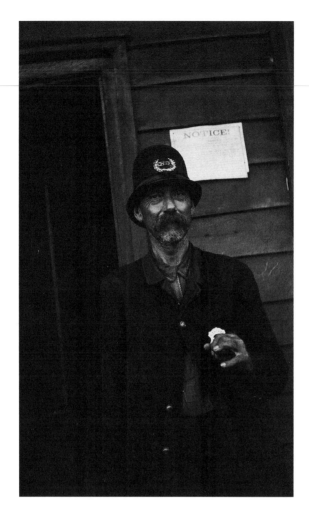

34. "The police force of
 Monck's Corner, S.C.,
 1904"

35. "A hoe gang bound for
 dinner"

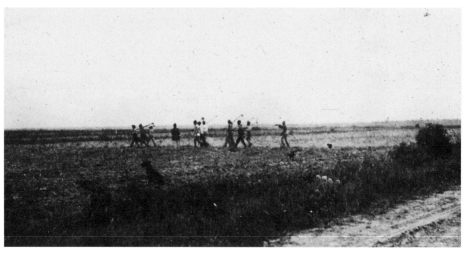

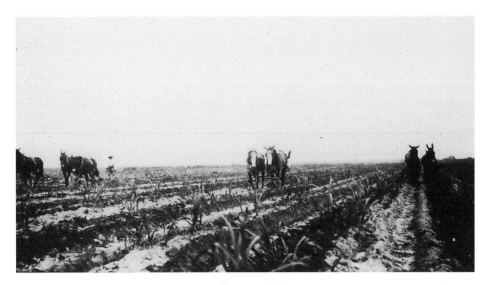

36 . "A battery of plows"

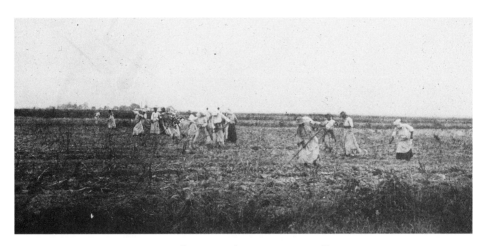

37. "Women chopping grass . . ."

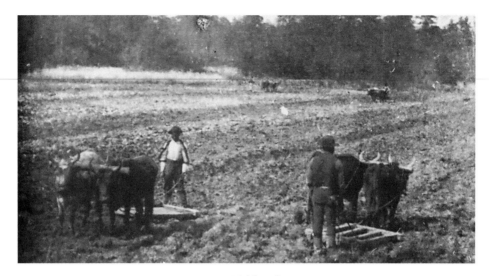

38. Fieldwork

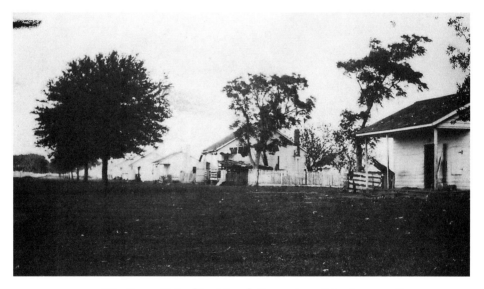

39. "On Bayou Teche [Louisiana]: Front view of the front row"

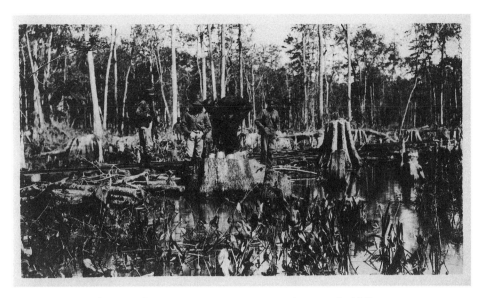

40. "The 'Lunch Room' in a cypress swamp (Bayou Black)," Louisiana

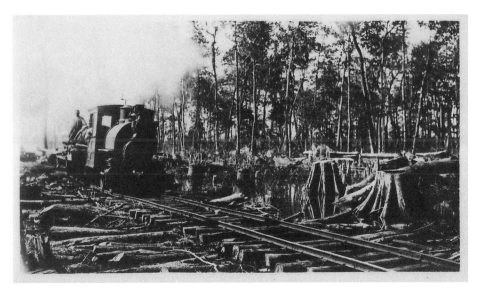

41. "'Dummy' locomotive in Skidder Camp (Bayou Black)"

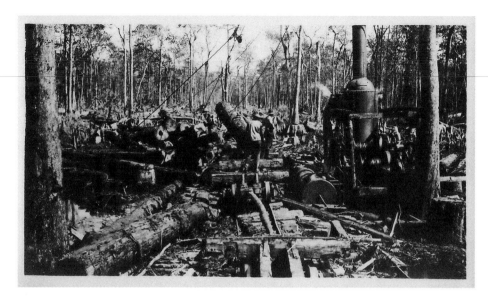

42. "Skidder loading cypress logs on cars (Bayou Black)"

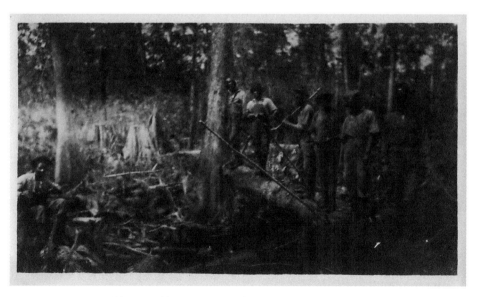

43. "Group of loggers (the 'chain gang') in the Bay Natchez Pull Boat Camp of the Kyle Lumber Company," Louisiana

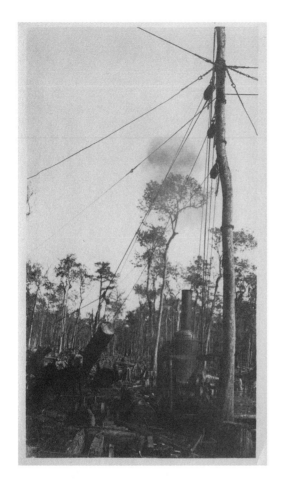

44. "Skidder loading a cypress log on Bayou Black"

45. Oxen and skidder, Bayou Black, Louisiana

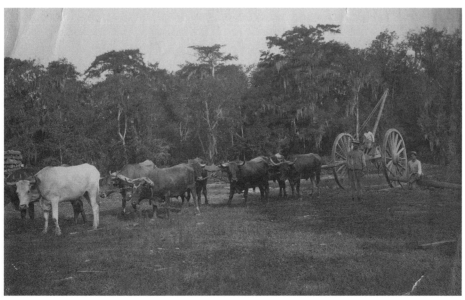

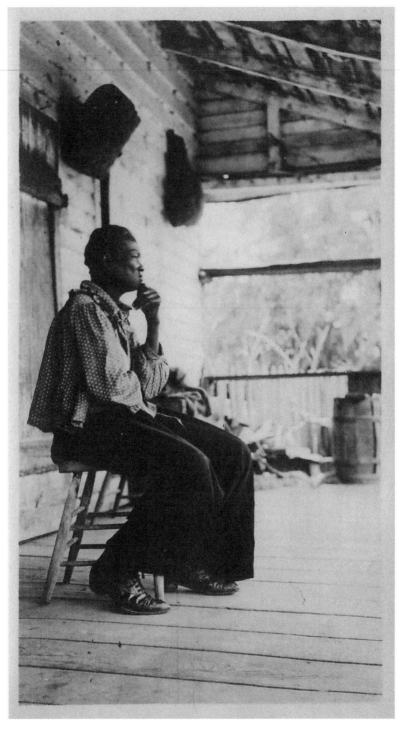

46. "Old Negro woman ..."

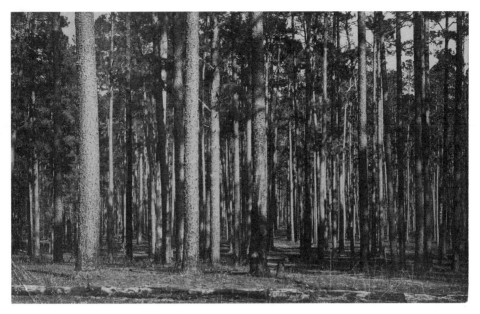

47. "Longleaf pine forest"

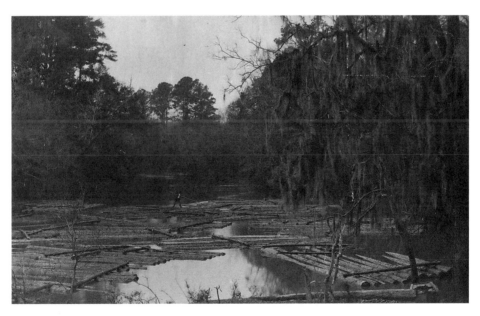

48. Log raft

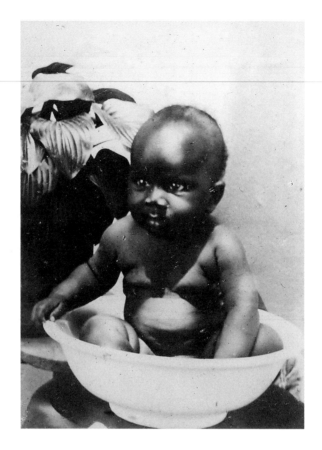

49. African Ameri-
can baby in
a bowl

50. African Ameri-
can youth

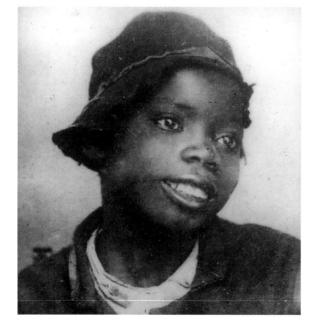

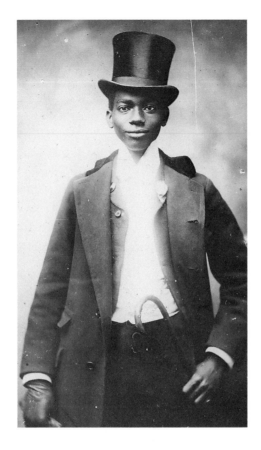

51. African American
 young adult

52. African American man

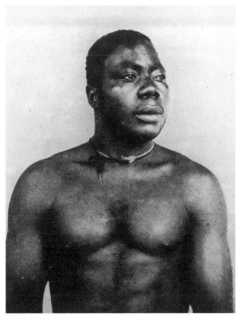

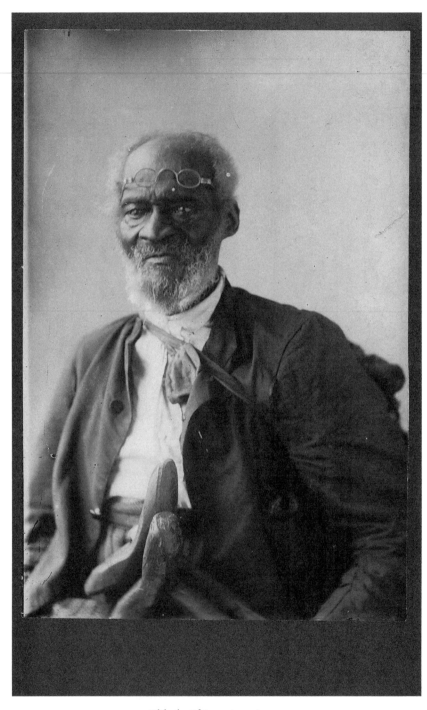

53. Elderly African American man

54. "A negro baptizing"

55. Baptism

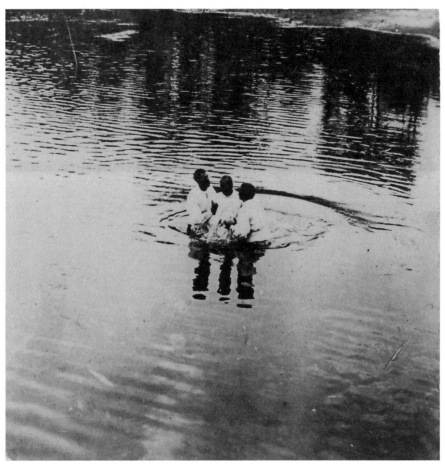

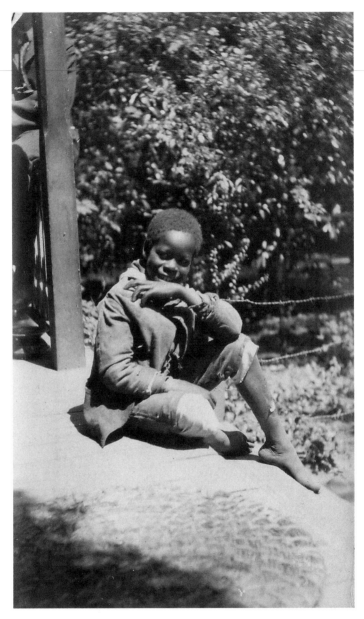

56. Young boy on a porch

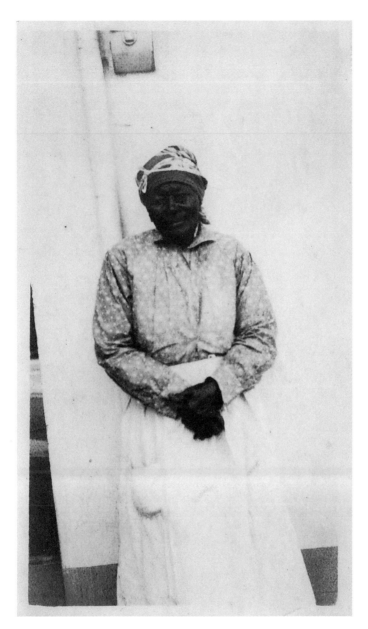

57. Woman in a doorway

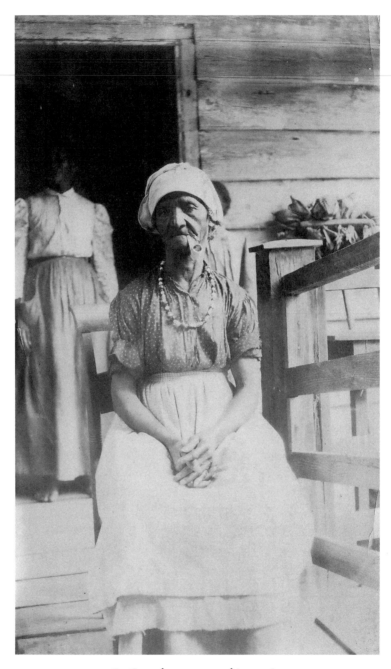

58. Seated woman smoking a pipe

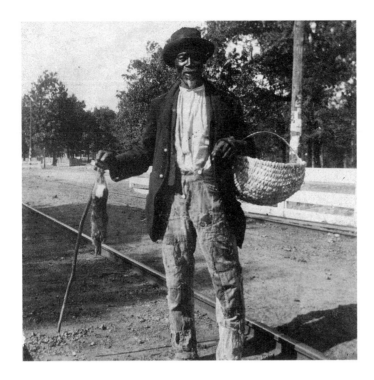

59. "Trousers à la
mode"

60. Woman with
children

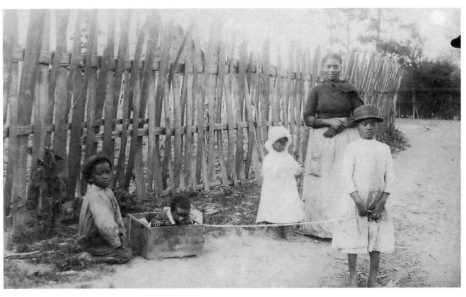

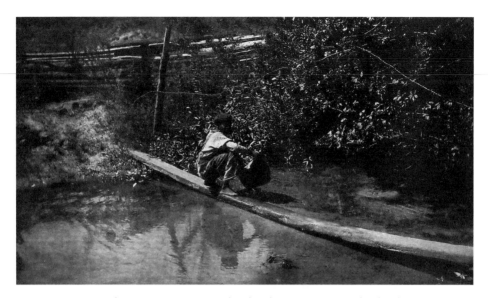

61. "A big spring, water supply of a plantation, in S.C. lowlands"

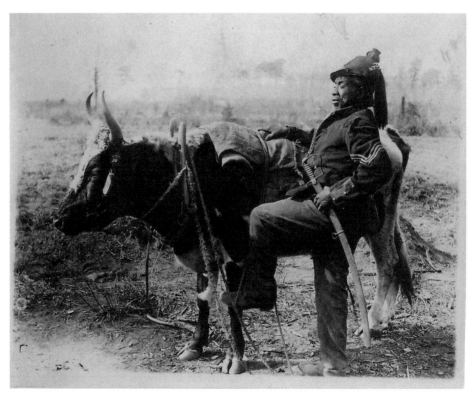

62. South Carolina militiaman

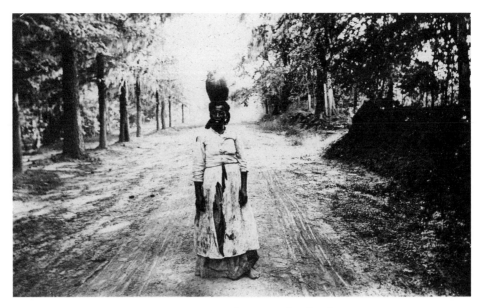

63. Woman with a jug on her head

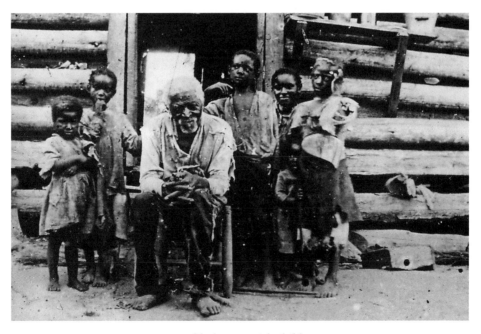

64. Elderly man with children

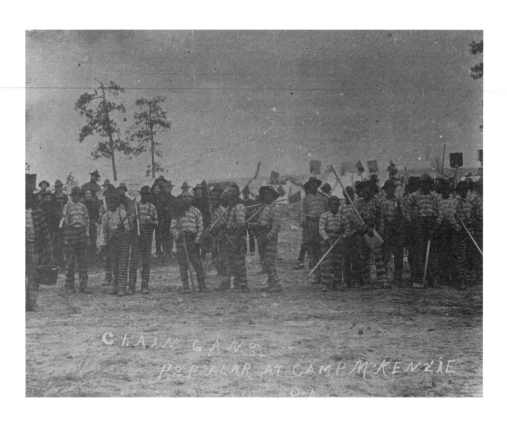

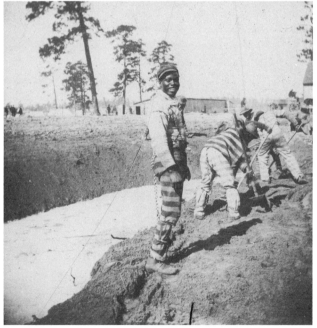

65. "Chain Gang Popular at Camp McKenzie Ga."

66. Convict

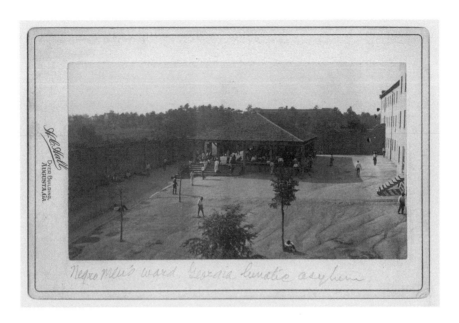

Negro Men's ward, Georgia lunatic asylum

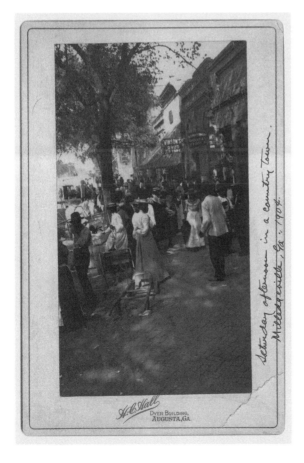

67. "Negro Men's ward, Georgia Lunatic Asylum"

68. "Saturday afternoon in a country town. Milledgeville, Ga. 1904"

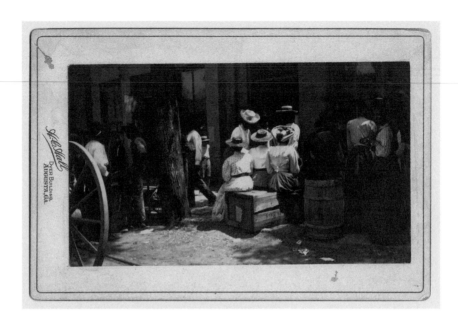

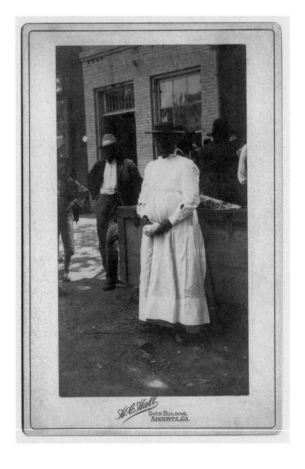

69. Saturday in
 Milledgeville,
 seated women

70. Saturday in
 Milledgeville,
 standing woman

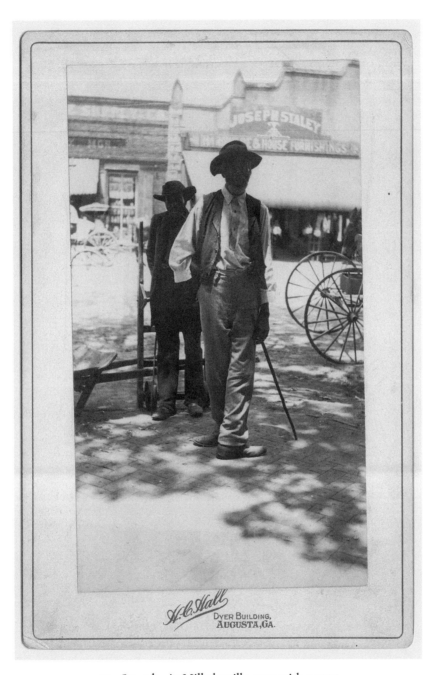

71. Saturday in Milledgeville, man with a cane

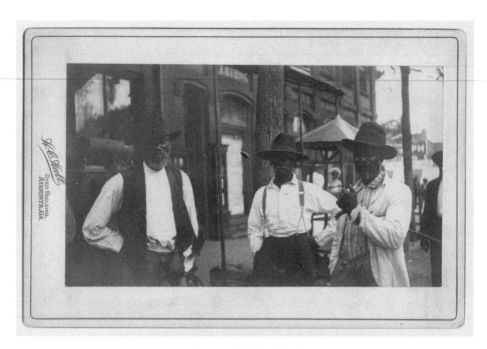

72. Saturday in Milledgeville, three men

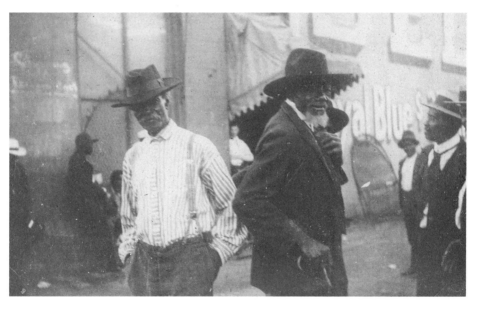

73. Saturday in Milledgeville, two men in street

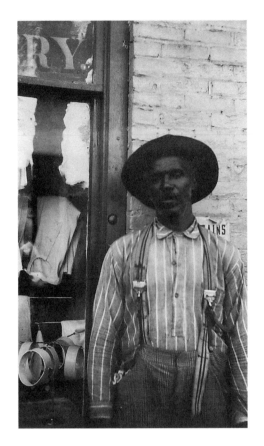

74. Saturday in Milledgeville, man wearing a striped shirt

75. Saturday in Milledgeville, couple

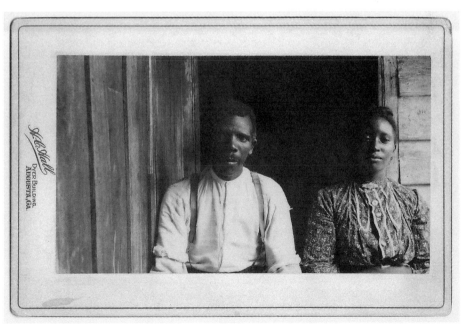

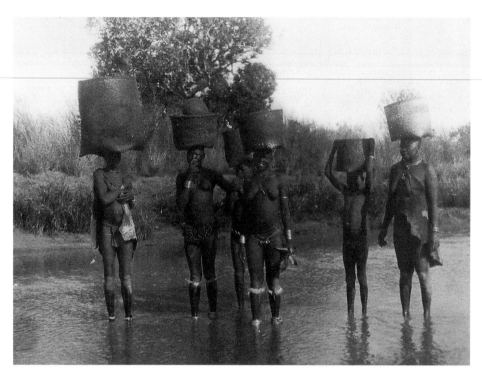

76. Africans with baskets

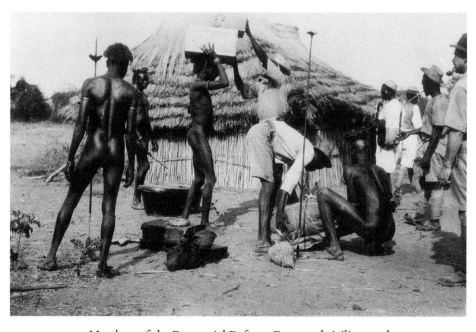

77. Members of the Equatorial Defence Force and civilian workers

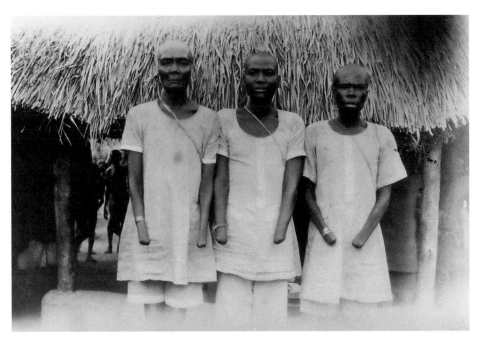

78. Azande convicts

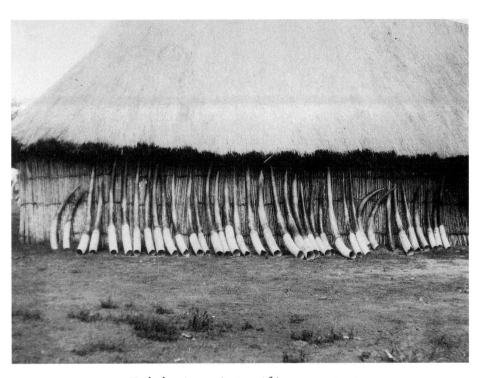

79. Tusks leaning against an African grass structure

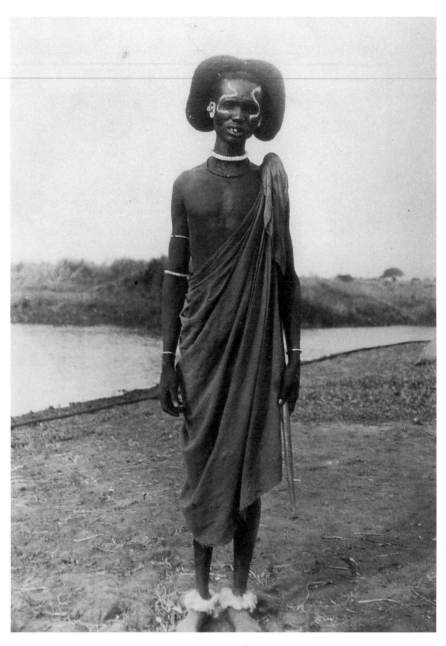

80. Young Dinka man

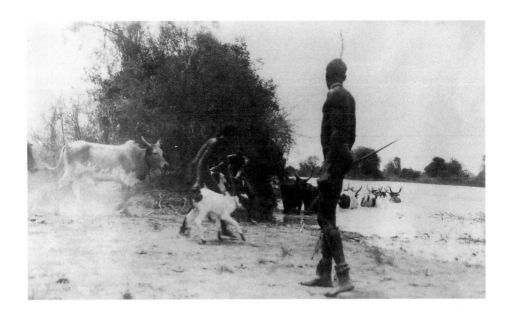

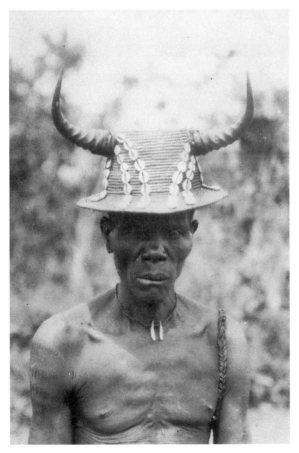

81. Men and livestock

82. Man with a horned hat

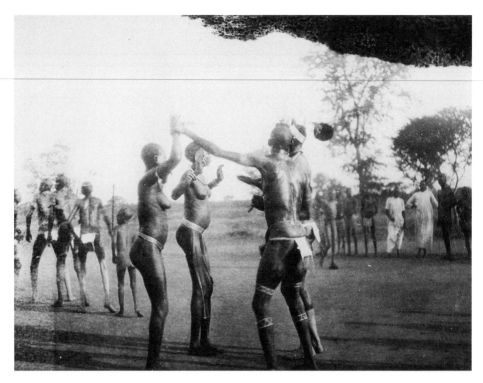

83. Dancing

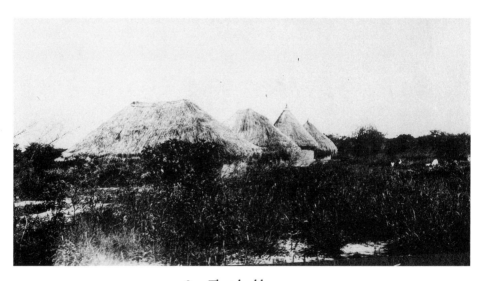

84. Thatched houses

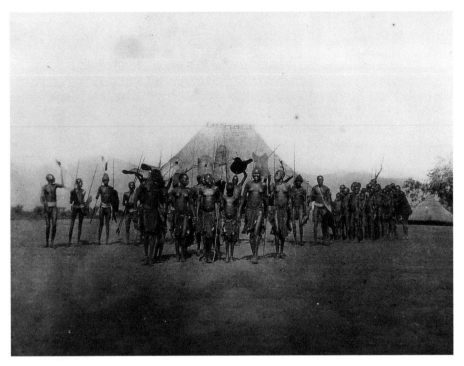

85. African tribal group

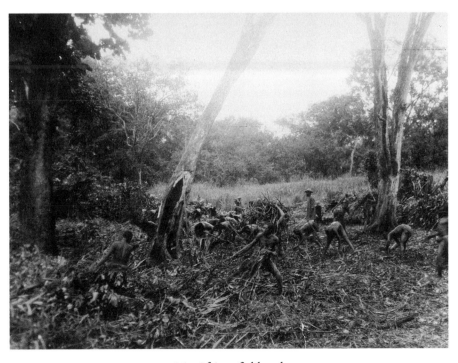

86. African fieldwork

87. African landscape

Appendix

Phillips's Annotations to Photographs

This appendix includes additional information from Phillips about the photographs in this book: published headings, captions, comments, and textual references as well as notations written on the photographs and/or their mountings. Whenever possible, photographers and publication history are provided. The term "illustrations list" refers to detailed descriptions published in the front matter of Life and Labor in the Old South. *The "Yale" number at the end of each item refers to the number assigned to the image in the MADID (Manuscripts and Archives Digital Images Database) by the Department of Manuscripts and Archives at the Yale University Library.*

Landscape and Architecture

1. Antebellum plantation home. Not published, photographer unknown (Yale 7042).
2. "[Antebellum] Plantation Home, S.C. lowlands" (notation in Phillips's handwriting on the mounting). Not published, photographer unknown (Yale 44198).
3. Plantation home. Not published, photographer unknown (Yale 7040).
4. "Mulberry Castle" (caption); "Mulberry Castle, on Cooper River, some twenty miles above Charleston. Built in 1714 by the Broughtons, it is reputed to have been a reproduction of Broughton Manor in England" (illustrations list). Published in *Life and Labor in the Old South,* photograph by Phillips (Yale 7064).
5. Approach to a plantation home. Not published, photographer unknown (Yale 70440).
6. "Avenue Within the Gate" (caption); "Avenue within the gate. The house to which this led was burned and has been replaced by a modern structure. Live oaks, draped in Spanish moss, give impressive settings to many homes in the lowlands from Carolina to Texas" (illustrations list). Published in *Life and Labor in the Old South,* photograph by Phillips (Yale 7046).
7. "Gateway to The Oaks" (caption); "Gateway to The Oaks, an estate neighboring Mulberry Castle" (illustrations list). Published in *Life and Labor in the Old South,* photograph by Phillips (Yale 7065).
8. "Slave quarters for slaves who worked at 'Big House' on E. S. C. Robertson plantation" (note on verso of photograph). Probably not published, photographer unknown (Yale 44211).
9. "Robertson Slave Quarters, Salado, Texas" (note on verso of photograph). Probably not published, photographer unknown (Yale 44212).
10. "E. S. C. Robertson—Plantation Home, Salado, Texas. This is said to be the best preserved plantation in Texas" (note on verso of photograph). Probably not published, photographer unknown (Yale 44213).
11. "In the Georgia Piedmont" (caption); "Contrasting in execution and upkeep, these houses are identical in plan, following faithfully the design of the log houses exemplified in the preceding plate"

(illustrations list, describing this image and two others not included here). Published in *Life and Labor in the Old South,* photograph by Phillips (Yale 7048).

12. "Cotton Gin House" (caption); "Cotton Gin House, equipped for horse power" (illustrations list). Published in *Life and Labor in the Old South;* the next caption implies that Phillips took this photograph circa 1900 (Yale 7070).

13. "Cotton baling press, with its great wooden screw visible near the base. These two photographs were taken in middle Georgia about 1900 when the structures were already antiquated by steam power and central ginneries. Under the gin house mules were hitched to a pivoted beam and driven round a circular path to send power through cogwheels to revolve the gin on the floor above. The lint accumulated in the shed room at the rear until it was carried to the press. There the mules revolved the sloping beams to force down the lid and pack the bales. An oak or hickory screw was preferred to cast iron because it would not break without warning" (illustrations list). Description from *Life and Labor in the Old South,* where Phillips included a similar image of the same kind of structure. Not published, photographer unknown (Yale 7069).

14. "Negro cabin built in 1906 for total outlay of $13.52. Woodlawn Plantation, Berkeley County, S.C." (note on verso of photograph). Not published, photographer unknown (Yale 7057).

15. Cabins. Not published, photographer unknown (Yale 44203).

16. "Plantation Schoolhouse, Cooper River, S.C." (note on verso of photograph). Not published, photograph likely by Phillips (Yale 44190).

17. Abandoned structure. Not published, photographer unknown (Yale 44189).

18. "Horizontal plowing and terracing in the cotton belt" with "slipshod terracing" (notation in Phillips's hand on verso of photograph). Not published, photographer unknown (Yale 44199).

19. Rice fields. Not published, photograph probably by Phillips (Yale 7079).

20. "Carting Sheaves of Rice" (caption); "Carting sheaves of rice to the stack yard for threshing. Photography by the author, 1907, on Jehossee Island, formerly the plantation of Governor William Aiken" (illustrations list). Published in *Life and Labor in the Old South,* probably part of a series, also including fig. 19, taken during Phillips's 1907 tour of South Carolina (Yale 7082).

Rural Life

"A Snug House of Logs" (heading for figs. 21 and 22
in *Life and Labor in the Old South*)

21. "Interior of Nessler's Cabin" (caption); "Interior of Nessler's cabin. The ceiling is papered with a dealer's samples, and the walls are completely hidden by various devices" (illustrations list). Published in *Life and Labor in the Old South* (image reversed), photograph from David Rankin Barbee (Yale 7038).

22. "George Nessler's Cabin" (caption); "George Nessler's home on Tackaseegee River, Jackson County, North Carolina. The hewn logs are well fitted, and the crib-work is carried to the peak of the roof—an unusual feature. Instead of daubing, the walls are neatly boarded inside. The original roofing of clapboards or 'shakes' has been replaced with corrugated iron" (illustrations list). Published in *Life and Labor in the Old South,* photograph from David Rankin Barbee (Yale 7049).

"Log Cabins with Blond Inmates and Brunette"
(heading for figs. 23 and 24 in *Life and Labor in the Old South*)

23. "In the North Carolina Mountains" (caption); "In the North Carolina mountains. The crudely built crib neither excludes the weather nor supports the logs of the loft floor. At the gable end,

where a smoke pipe protrudes, a chinking with split logs and a daubing with mud has made a wall; at the front, vertical boarding serves instead. Photograph, 1928, supplied by Mr. D. R. Barbee" (illustrations list). Published in *Life and Labor in the Old South* (Yale 7053).

24. "In the Lowlands" (caption); "In the lowlands: a negro cabin of round logs well notched. The source of the photograph is forgotten; but the basket of white-oak splits places it presumably in the cotton belt, and the glimpse of the chimney—clay daubed upon cribbed sticks—suggests the district between Charleston and Savannah" (illustrations list). Published in *Life and Labor in the Old South*, photograph from David Rankin Barbee (Yale 7054).

THE PLAIN FOLK

25. "The height of style in logs" (caption); "Armentrout home, six miles north of Lexington, Virginia. The squared logs are nicely dovetailed and plumbed, and their interstices are chinked with small slabs of limestone and plastered with white mortar. The slots for the joists of the second floor are visible. The porch, with scroll-saw decorations, is of course an addition at a much later time. Photograph procured through the courtesy of Mr. Herbert A. Keller of Chicago" (illustrations list). Published in *Life and Labor in the Old South* (Yale 7047).

"Double and Triple Cabins" (heading for
figs. 26 and 27 in *Life and Labor in the Old South*)

26. "A Triple Log Cabin" (caption); "A triple log cabin in Cherokee County, Alabama. The corner of the third room is visible through the passage separating the front rooms. In the foreground is a thin crop of cotton" (illustrations list). This is a better, reversed and tilted version of an image published in *Life and Labor in the Old South*, photograph by Phillips (Yale 7050).

27. "Remnant of a Double Frame Cabin" (caption); "Remnant of a double frame cabin in the South Carolina lowlands. For economy of brick the chimney was built in the middle. Half of the house has been demolished. The woman and her twins indicate the scale of the fireplaces, which served of course for cooking as well as heating" (illustrations list). Published in *Life and Labor in the Old South*, photograph by Phillips (Yale 7051).

28. A triple log cabin photographed from the road; given the placement of trees and cotton planting in front of and around house, it could be the same structure shown in fig. 26. Not published, photograph probably by Phillips (Yale 7052).

29. "A Georgia poor white 1902" (note on verso of photograph). Not published, photograph possibly by Phillips (Yale 44214).

30. "W. T. Paris Cabin on the banks of the Tuckaseegee" (crossed out); "Plate XXI Vines and Flowers Cabin of W. T. Paris on Tuckaseegee River in the North Carolina Mountains"; "Michael Studio Citizen Bldg" (notes on verso of photograph). Perhaps intended for publication in *Life and Labor in the Old South;* most likely obtained from David Rankin Barbee (Yale 44205).

31. "Overseer—Waterproof Plantation" (note on verso of photograph). Photograph probably by Phillips (Yale 44306).

32. "Mr. Allain (mounted) and Mr. Proctor Overseers Albamia Plantation" (note on verso of photograph). Photograph probably by Phillips (Yale 44307).

33. "Hands at noon, Dunleith, Miss." (note on verso of photograph). Photograph probably by Phillips (Yale 44182).

34. "The police force of Monck's Corner, S.C., 1904" (note on verso of photograph). Photograph probably by Phillips (Yale 44300). There are other Monck's Corner images in the collection.

Working

"Gangs in the Cane Field" (heading for figs. 35 and 36
and one other image in *Life and Labor in the Old South*)

35. "A hoe gang bound for dinner" (caption); "Men's hoe gang briskly bound for dinner. These photographs [figs. 35, 36, and one other], taken on Bayou Teche in the spring of 1909, were presented by Mr. B. G. Fernald" (illustrations list); "Albamia Plantation" (crossed out on verso of photograph). Published in *Life and Labor in the Old South*, photograph from Benjamin G. Fernald, referred to as "an engineer and citizen at large" in the front matter for *Life and Labor in the Old South* (Yale 7078).

36. "A battery of plows" (caption); "A battery of plows. These photographs, taken on Bayou Teche in the spring of 1909, were presented by Mr. B. G. Fernald" (front matter); "Plate XVI, no. 1; Plowing cane Albamia Plantation" (crossed out on verso of photograph). Published in *Life and Labor in the Old South*, photograph from Benjamin G. Fernald (Yale 7080).

37. "Plate XVII, no. 2; Women chopping grass from roots of cane stalks and loosening the soil on Albamia Plantation" (crossed out on verso of photograph). Not included in *Life and Labor in the Old South*, but this image is similar to one of the same group of women provided by Fernald, used with figs. 35 and 36 in that volume, and captioned: "Women hoeing sugar cane" (Yale 7066).

38. Fieldwork. Not published, photographer unknown (Yale 7033).

39. "Slave Quarters" (heading for this and other photographs); "On Bayou Teche: Front view of the front row" (caption); "On Bayou Teche, in Louisiana: front view of the front row of cabins on a sugar plantation.... Photographs, 1909, by Mr. Benjamin G. Fernald, an engineer and citizen-at-large" (illustrations list); "Plate X, no. 2 Front view of front row of 'quarters' on Bayou Teche on plantation next above the 'Calumet' Sugar House could not learn name of owner, but think is 'Zeno' the most extensive quarters seen on trip BEJJ [unclear]" (note in Phillips's hand on verso of photograph). Published in *Life and Labor in the Old South*, photograph from Benjamin G. Fernald (Yale 44191).

40. "The 'Lunch Room' in a cypress swamp (Bayou Black). Negros [*sic*] predominate in cypress logging" (note in Phillips's hand on verso of photograph). Not published, photographer unknown (Yale 44207).

41. "'Dummy' locomotive in Skidder Camp (Bayou Black)" (note in Phillips's hand on verso of photograph). Not published, photographer unknown (Yale 44208).

42. "Skidder loading cypress logs on cars (Bayou Black)" (note in Phillips's hand on verso of photograph). Not published, photographer unknown (Yale 44209).

43. "Group of loggers (the 'chain gang') in the Bay Natchez Pull Boat Camp of the Kyle Lumber Company" (note in Phillips's hand on verso of photograph). Not published, photographer unknown (Yale 44210).

44. "Skidder loading a cypress log on Bayou Black" (note in Phillips's hand on verso of photograph). "Skidder loading a cypress log on Bayou Black." Not published, photographer unknown (Yale 44215).

45. Oxen and skidder, Bayou Black, Louisiana. Not published, photographer unknown (Yale 44216).

46. "Old Negro [or Indian] woman on place formerly Judge Bakers Bayou Teche—there 30 years about 65 years old born at Opelousas—spoke English" (note in Phillips's hand on verso of photograph). Not published, photographer possibly Phillips or Fernald (Yale 44183).

47. "Longleaf pine forest" (note in Phillips's hand on verso of photograph). Not published, photographer unknown (Yale 7067).

48. Log raft; photograph found with fig. 47 in one of the two envelopes containing the logging series. Not published, photographer unknown (Yale 44206).

African Americans

The bulk of these images seem to be the work of Robert E. Williams, an African American photographer who had a studio in Augusta, Georgia.

49. "Use Wool Soap" (written in pencil across the top); African American baby in a bowl (Yale 7092). Another print is in the Williams Collection, Hargrett Rare Book and Manuscript Library, University of Georgia, Athens.

50. African American youth. A confirmed Williams Studio image (Yale 7090). Another print is in the Williams Collection, Hargrett Rare Book and Manuscript Library, University of Georgia, Athens.

51. African American young adult (Yale 7091). Another print is in the Williams Collection, Hargrett Rare Book and Manuscript Library, University of Georgia, Athens.

52. African American man. Photograph probably by Williams (Yale 7094). Another print is in the Williams Collection, Hargrett Rare Book and Manuscript Library, University of Georgia, Athens.

53. Elderly African American man. Photograph probably by Williams (Yale 44186). Another print is in the Williams Collection, Hargrett Rare Book and Manuscript Library, University of Georgia, Athens.

54. "A negro baptizing" (on verso of photograph), part of a series of baptism images that also includes fig. 55. Photograph by Williams (Yale 7085). Another print is in the Williams Collection, Hargrett Rare Book and Manuscript Library, University of Georgia, Athens.

55. Baptism. Photograph probably by Williams (Yale 44179). This photograph is most likely part of a longer Williams Studio baptism series in the Williams Collection, Hargrett Rare Book and Manuscript Library, University of Georgia, Athens.

56. Young boy on a porch. Photograph probably by Williams (Yale 44180). The rest of the images in this section conform stylistically and by subject with images from the Williams Studio; similar photographs may be found in the Williams Collection, Hargrett Rare Book and Manuscript Library, University of Georgia, Athens.

57. Woman in a doorway. Photograph probably by Williams (Yale 44181).

58. Seated woman smoking a pipe. Photograph probably by Williams (Yale 44184).

59. "Trousers à la mode," a man with a basket and a rabbit (notation in Phillips's hand on verso of mounting). Photograph probably by Williams (Yale 44185).

60. Woman with children. Photograph probably by Williams (Yale 44187).

61. "A big spring, water supply of a plantation, in S.C. lowlands," showing a boy balanced on a log over stream (notation in Phillips's hand on recto of mounting). Photograph probably by Williams (Yale 44188).

62. South Carolina militiaman. Photograph possibly by Williams (Yale 44188). This image exists in many photographic collections from the period. It appears in the Yale Phillips Collection with other miscellaneous prints.

63. Woman with a jug on her head. Photograph probably by Williams (Yale 7088).

64. Elderly man with children. Photograph probably by Williams (Yale 7089).

65. "Chain Gang Popular at Camp McKenzie Ga" (inscribed on postcard). Photograph probably by Williams (Yale 44192). Similar images of convicts exist in the Williams Collection, Hargrett Rare Book and Manuscript Library, University of Georgia, Athens.

66. Convict. Photograph probably by Williams (Yale 7095).

67. "Negro Men's ward, Georgia Lunatic Asylum" (notation in Phillips's hand on mounting). Photograph probably by Williams (Yale 44194).

Saturday Afternoon, Milledgeville, Georgia, 1904

Identifying information for this series is from Phillips's note on fig. 68. The other images are set in the same locality and include some of the same people.

68. "Saturday afternoon in a country town, Milledgeville, Ga., 1904" (notation in Phillips's hand on recto of mounting). Not published, photographer unknown (Yale 44195).
 69. Seated women. Not published, photographer unknown (Yale 44196).
 70. Standing woman. Not published, photographer unknown (Yale 44197).
 71. Man with a cane. Not published, photographer unknown (Yale 44200).
 72. Three men. Not published, photographer unknown (Yale 44202).
 73. Two men in street. Not published, photographer unknown (Yale 44204).
 74. Man wearing a striped shirt. Not published, photographer unknown (Yale 44229).
 75. Man and woman. Not published, photographer unknown (Yale 7086).

African Photographs

These images exist in the Yale Phillips Collection only as negatives in a single envelope marked "Congo Jan 1929." The photographs correspond with events and people Phillips described in his various writings about his time in Africa during his Kahn Fellowship year. The quoted captions below derive from "Negroes of the Sudan," a typescript included among the Phillips Papers.

76. Africans with baskets. Photograph by Phillips (Yale 44217).
 77. Members of the Equatorial Defence Force and civilian workers: "They offer themselves copiously as recruits for the Equatorial Defence Force, and make a smart appearance in its uniform of khaki shorts and blouses and cockaded hats. Erect posture is already theirs, for the habitual carrying of burdens on the head forbids a stooping shoulder or bending neck.... In civilian employment they prefer service as government carriers because that yields a wage of two and a half piastres per day as compared with one piaster ... which is the prevailing scale for other sorts of work." Photograph by Phillips (Yale 44218).
 78. Azande convicts: "Not many decades ago the Azande were conquered by invading Avungara who settled among them as a ruling caste. Numerous Vungara chiefs are still dwelling in their midst; and as a symbol of their previous regime I saw on my tour half a dozen Zande men whose voices betrayed emasculation and whose arms ended in stumps at the wrist. In earlier life each of these men was tried by some primitive method, convicted of adultery with a chief's wife, and mutilated in barbarous punishment. The Vungara tyranny doubtless inclined the Azande toward a more willing acquiescence in the coming of British rule." Photograph by Phillips (Yale 44219).
 79. Tusks leaning against an African grass structure. Photograph by Phillips (Yale 44220).
 80. Young Dinka man: "The men ... range in stature from little less than six feet toward nearly seven. Their hands and feet are extremely narrow, and their bodies very slim. They are unmistakably Negroes, with complexions as black as the blackest, but their forms and faces are seldom similar to those encountered in America.... Their men are clad in cotton togas, knotted on the left shoulder and

preferably tinted red.... Young Dinka men stuff their hair with red ash and train it somewhat into the shape of an old-time English lawyer's wig." Photograph by Phillips (Yale 44221).

81. Men and livestock: "[There is] unlimited grazing when it is accessible. But in high water the cattle ... are driven scores of miles to higher grounds when the rains produce green grass there.... he tends its grazing by day; at dusk he tethers it in a selected spot ... and through the night he maintains a smudge to prevent mosquitos from disturbing the bovine slumber." Photograph by Phillips (Yale 44222).

82. Man with a horned hat: "The wearing of hats is confined to the men and more or less restricted to festive occasions.... the crown, having no whorl, is of square outline. When the weaver has completed this he bends the straws to the vertical on the four sides and interlaces new straws with them to build a cylinder. Of course the cylindrical side and the square top will not conform. The solution is reached by merely leaving a hole in the weave at each corner of the crown's edge." Photograph by Phillips (Yale 44223).

83. Dancing: "In ranks all round were the dancers, men and women in separate lines, advancing and retreating or circling to the right or left, everyone postured loosely with knees bent a little to take the weight off the heels, forearms horizontally forward, palms up and fingers laxly curved." Photograph by Phillips (Yale 44224).

84. Thatched houses: "The dwellings to be seen in the whole of my tour through Negro lands were of a single type—a conical roof of thatch above a thin circular wall of mud." Photograph by Phillips (Yale 44225).

85. African tribal group. Photograph by Phillips (Yale 44226).

86. African fieldwork. Photograph by Phillips (Yale 44227).

87. African landscape. Photograph by Phillips (Yale 44228).

Index

ABOUT THE AUTHORS

PATRICIA BIXEL is a professor of history and chair of the Department of Arts and Sciences at Maine Maritime Academy in Castine, Maine. A former assistant editor for the *Journal of Southern History,* Bixel is coauthor, with Elizabeth Hayes Turner, of *Galveston and the 1900 Storm* and author of *Sailing Ship Elissa.*

JOHN DAVID SMITH is the Charles H. Stone Distinguished Professor of American History at the University of North Carolina at Charlotte. His previous books include *Ulrich Bonnell Phillips: A Southern Historian and His Critics; An Old Creed for the New South: Proslavery Ideology and Historiography, 1865–1918;* and *Black Judas: William Hannibal Thomas and "The American Negro,"* winner of the Mayflower Society Award for Nonfiction in 2000.